IMAGES
of America
BRAINERD

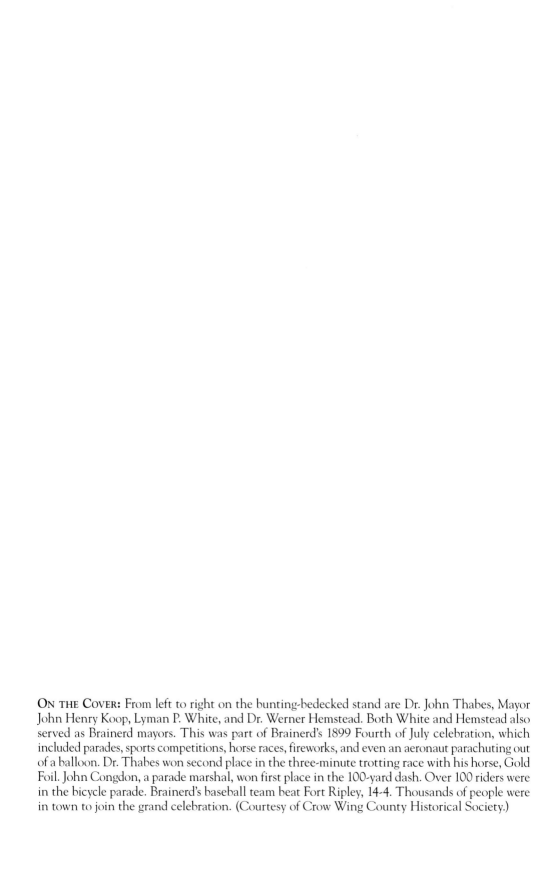

ON THE COVER: From left to right on the bunting-bedecked stand are Dr. John Thabes, Mayor John Henry Koop, Lyman P. White, and Dr. Werner Hemstead. Both White and Hemstead also served as Brainerd mayors. This was part of Brainerd's 1899 Fourth of July celebration, which included parades, sports competitions, horse races, fireworks, and even an aeronaut parachuting out of a balloon. Dr. Thabes won second place in the three-minute trotting race with his horse, Gold Foil. John Congdon, a parade marshal, won first place in the 100-yard dash. Over 100 riders were in the bicycle parade. Brainerd's baseball team beat Fort Ripley, 14-4. Thousands of people were in town to join the grand celebration. (Courtesy of Crow Wing County Historical Society.)

IMAGES
of America

BRAINERD

Crow Wing County Historical Society

ARCADIA
PUBLISHING

Published by Arcadia Publishing
Charleston, South Carolina

Printed in the United States of America

Library of Congress Control Number: 2013936566

For all general information, please contact Arcadia Publishing:
Telephone 843-853-2070
Fax 843-853-0044
E-mail sales@arcadiapublishing.com
For customer service and orders:
Toll-Free 1-888-313-2665

Visit us on the Internet at www.arcadiapublishing.com

This book is dedicated to all the generous donors throughout the years who have given their stories, photographs, and artifacts to the Crow Wing County Historical Society to keep history alive for generations to come.

CONTENTS

ACKNOWLEDGMENTS

Writing a book about historic events and people takes a considerable amount of time and talent. As the author of this book, the Crow Wing County Historical Society would like to commend and thank the following people involved with this historic adventure:

We thank the board of directors for allowing staff and volunteers the time to compile this book, Lucille Kirkeby for writing the introduction and for her dedication to our museum's research library archival collections so that the information could be compiled, Lynda Hall and Darla Sathre for digging into the past and writing the captions and selecting photographs, Ray Frisch for proofreading the text, volunteers Brian Marsh and Dana Moen for their assistance with research, and local historians Carl Faust and Ann Nelson for sharing their knowledge and photographs, as well as their proofreading.

Special thanks go to the Brainerd Public Library and to branch manager Jolene Bradley for allowing us to include the Thomas Congdon painting *The Last Kiss of the Sun* in chapter nine. A thank-you goes to the following people for letting us borrow their photographs and allowing us to make them part of our archives: Elaine Axtell, Kathy Bjork, Janna Congdon, Carl Faust, Shirley Jensen, and Ann Nelson.

The scanning of photographs was implemented by executive director Pamela Nelson and volunteer Mary Ann Frisch. We want to thank George Hooper and Angela Anderson for technical support.

We especially want to thank Darla Sathre for her enthusiasm and vision for a "Brainerd book."

On a special note, some readers may wonder why something or someone was not included. Our archives include photographs, historical events, and stories that have been donated to the Historical Society Museum since its humble beginnings in 1927. Therefore it does not include everything. And a thank-you goes to Arcadia Publishing editor Jill Nunn for her advice and support. Unless otherwise noted, all images appear courtesy of the Crow Wing County Historical Society.

—Pamela Nelson

INTRODUCTION

Brainerd, located on the upper Mississippi River, came into existence because of railroad expansion to the West. The government wanted to connect the head of the Great Lakes and the Pacific Ocean for military reasons, as well as to open and settle the West, which was the new frontier of the nation.

Building the railroad began in February 1870 at Carlton, located about 20 miles west of Duluth. Since the railroad had to cross the Mississippi somewhere, surveyors examined various places. In the running were the Beaulieau-Morrison trading post at Old Crow Wing and French Rapids near Brainerd. In June 1870, a point about midway between the previously considered routes was chosen, and a camp was pitched on the east side of the river.

For lack of a more picturesque name, the place was simply known as the Crossing. Lyman P. White was sent by the railroad to act as an agent for the Lake Superior and Puget Sound Land Company. His job was to oversee the surveying and platting of townsites at the Crossing. Advantages for the region were the nearness to the Leech Lake military trail, a foot trail used by traders, and the thick forests holding great promise for lumbering. However, the objective of the railroad was to colonize the area and create townsites.

At its very earliest, the Crossing consisted of numerous tents and one building, which was the shack used as the temporary office of Lyman P. White. By October 1870, the second building, a hotel and boardinghouse, went up at the Crossing. The third building was a saloon, and the fourth was the private residence of Lyman P. White.

By early March, the very important large wooden trestle bridge over the Mississippi was completed. On March 11, 1871, the first railroad cars arrived. In the early days, trains came frequently, but on an irregular schedule as needed. With the coming of the train bringing passengers, more building was necessary. In 1872, completed structures included the Headquarters Hotel, a three-story depot with general offices of the Northern Pacific Railroad, and car repair shops.

A plat filed with the Register of Deeds on October 25, 1871, bore the name Brainerd rather than the Crossing. Where did that name come from? John Gregory Smith, president of the Northern Pacific Railroad, was married to Eliza Brainerd, daughter of a Vermont senator and businessman. Perhaps the name was chosen to honor his wife or in memory of her father, who had passed away recently. Whatever the reason, we can safely say that Brainerd was the maiden name of the wife of the Northern Pacific president. Other family names were also used, such as Gregory Park. There was a time when Lawrence was considered as a name for West Brainerd; Lawrence was Eliza's father's first name.

As soon as the townsite was platted, Brainerd became the county seat of Crow Wing County. Soon, other buildings began to spring up. In 1871, there was an Episcopal church and a Catholic church. In that same year, Eber Bly opened the first general mercantile store, George Holland came to practice law, and Wilder Hartley erected many buildings to rent and also published a newspaper.

By the time 1872 came to a close, a fire department was being organized, a small sawmill had begun operation near the railroad bridge, and there were already five churches in town. There was a post office, but there was no official building to house it. Therefore postal services were moved from business to business when necessary.

These years saw an increase in spending on education. In 1873, the school district voted to build a public school, so the Sixth Street School was built and open for its first term the following year. Soon, several other smaller schools were built.

The panic of 1873 affected Brainerd and the Northern Pacific Railroad. The railroad went into receivership, and the general offices of the railroad were transferred to St. Paul, but Brainerd retained the division offices. Two years of hard times followed. Business was paralyzed and there was very little new development; however, the population had grown to 931 by 1875. In July of that year, a freight train was moving along the railroad bridge when part of the bridge collapsed, sending the engine and numerous cars of rails and other merchandise into the river below.

The situation began to improve by 1879. A direct rail connection had been built from Brainerd to St. Paul as early as 1877. Building of the railroad to the West Coast was resumed as well as the building of branch lines. This meant more work for Brainerd shops and sawmills, which translated to greater employment and more money earned and spent in the area. By 1879, William Ferris and George Holland saw the need for a bank and chartered the Bank of Brainerd, which became the First National Bank in 1881.

By 1880, the population had grown to 1,864 and to a whopping 7,150 by 1885. With the end of the receivership, the Northern Pacific Railroad planned for expansion of its facilities. This included enlargement of the Brainerd shops in 1881 to accommodate the employment of 1,200 men.

In the 1880s, logs were floated from northern forests to sawmills at Brainerd; however, a hundred million feet were sent through Brainerd to sawmills farther south. Merchants thrived on outfitting the lumberjacks both going in and coming out of the woods. Some public utilities were started in this period with little or no capital.

During this decade the biggest blow to Brainerd was the completion of the railroad cutoff from Little Falls to Staples, bypassing Brainerd. Brainerd lost the division headquarters and was not on the direct rail line between St. Paul and the Pacific coast.

The 1880s and 1890s saw many changes to Brainerd. The brick-making industry was thriving between 1880 and 1888. The Schwartz Brainerd Steam Brickyard became famous for making a cream-colored brick, still seen in some of the older Brainerd buildings. Ebinger Brickyard produced red brick but not in the quantities of the Schwartz cream brick.

Charles F. Kindred started a street railroad pulled by horses or mules in 1885, which was revived as an electric railroad in 1892 by Charles N. Parker. Public utilities, such as water and electric service, started early with power derived from a dam on the river but these were not necessarily reliable. In 1882, the city issued bonds to build a courthouse, a sheriff's residence, and a jail. During the early 1880s, numerous talented businessmen came to Brainerd. Cornelius O'Brien started a saloon and, later, a mercantile store. Brainerd had no dentist prior to 1883. Barbers usually pulled teeth, and even a veterinarian advertised tooth extraction.

The railroad was in the center of news events in Brainerd. It established a hospital in the Immigration Hall building. Even bigger news was that the transcontinental line, west from Carlton and east from Tacoma, met in 1883 at Gold Creek in Montana. With the good news also came the bad. The railroad dealt Brainerd a blow when it moved its car shops from Brainerd to St. Paul with a loss of 500 jobs. By 1893, however, the railroad began building wooden boxcars here. Brainerd's business barometer definitely responded to the fluctuation in railroad business.

About the same time, two of the largest industries were the Brainerd Lumber Company and the J.J. Howe Mill. Soon, the lumber business began to fade. In 1896, Jeremiah Howe's mill burned and was never rebuilt because the forests were becoming depleted.

Other events of the 1890s need mentioning, such as the surfacing of streets and sidewalks with wood and gravel to ease navigation in the deep sand. In 1898, a tornado knocked down much of the large stand of pine in Gregory Park and took out the bridge used by the street railroad over

the ravine, ending the street railroad service in town. Another railroad, the Brainerd & Northern Minnesota Railway Company, came to town. Brainerd began shipping out goods by rail, including huge quantities of blueberries, cranberries, and wild rice.

From 1900 to 1910, many people left Brainerd, but new homesteaders and settlers arrived. The railroad was really pushing to populate the cutover lands. Agriculture grew in importance, and the farmers asked for a hay market in town. Iron deposits were found in the county and even in Brainerd. Mine workers and their families began to arrive. Brainerd was finally becoming aware of its surrounding territory and of how newly discovered resources would affect the growth and economics of the city.

During the next decade, Brainerd was still having problems with its public utilities. A fire in 1910 at the municipally owned generating plant plunged the city into darkness. A few years later, when saloons and the thriving Brainerd Brewery were forced to close because of the law banning liquor in Indian Territory, Brainerd utilities again took a hit. Saloon license fees of $750 per establishment paid for the lights, the hydrant rentals, and the water for public buildings and parks. Unfortunately, lights were often turned off for nonpayment. In 1910, a post office building was erected on Sixth Street. The following year, the wooden bridge over the ravine was replaced by filling in the area so that a road could be constructed. In 1914, Brainerd City Hall and a new fire hall were built.

Between 1915 and 1917, a paper mill was started. It employed 185 people and used 13,000 cords of wood per year. During this time, Brainerd still did not have a proper water supply. In 1916, the state Insurance Commission informed the chamber of commerce that Brainerd had had too many fires and that insurance companies covering Brainerd were in the red. They would cancel their coverage unless there was an improvement in firefighting capability. Brainerd did meet the challenge, but it took four years. The water tower was built from 1919 to 1922. A new electricity-generating gas plant was finally operational by 1924. Hard-surfacing of streets made great progress in the 1920s with the use of cement.

The railroad industry made history again in 1922 when employees went on a strike that lasted until February 1923. Unfortunately, many strikers lost their jobs and were blacklisted from ever working on the railroad again. The 1920s were also a decade of retail growth. Companies such as Woolworths, Montgomery Ward, Red Owl, National Tea, Coast to Coast, and Sears came to Brainerd. Auto dealerships also arrived on the scene.

The 1930s began with a population of 10,221 and ended with 12,071. Despite the worst depression that the nation had seen, Brainerd seemed to make a lot of progress during this decade. In 1930, the new Washington High School was ready to be occupied and Franklin Junior High by 1933. The Works Progress Administration in 1936 was involved in the building of Lincoln, Whittier, Lowell, and Harrison elementary schools. The junior college was started in 1938, but it had to share space with the high school. The Washington Street Bridge opened in 1932. St. Francis Catholic Church rebuilt for the second time after a 1933 fire. The paper mill shut down for about 10 months, but was refitted to make wallpaper and began operations again in 1935. A complete storm sewer system was in place by 1936, and the armory was also built that year. Oil burners began to replace coal for winter heating.

Progress had been steady in the mid-1930s and into the 1940s. By 1945, Brainerd had a privately owned nursing home. In the mid-1940s, a federal license was granted to establish a radio station in town with the call letters KLIZ. The new St. Joseph's Hospital was completed, and the Mill Avenue Bridge was also finished. The year 1947 saw the beginning of scheduled air travel; Wisconsin Central Airlines, which later became North Central Airlines, built a small wooden terminal building. By 1949, a new terminal was built. Brainerd State Hospital was built, and the first patients were housed at that facility in 1948.

World War II left a mark on Brainerd as about 1,400 Brainerd men joined the ranks of the armed forces. In 1942, some Allies, including the 194th Tank Battalion, were forced to surrender at Bataan in the Philippines. This resulted in a forced march to Camp O'Donnell, which became known as the Bataan Death March. Among the casualties were many of Brainerd's finest men.

Today, the tourist industry fuels Brainerd's economy, but agriculture still remains important as well. The school system and the medical community also provide many jobs. Government and other service industries add to the community's economic strength. Brainerd's central location puts it in a relatively large trade area, which sustains small businesses as well.

History has shown that it is a rare city that can rely completely on one industry to keep its economy intact and keep the town alive. Brainerd has survived the exodus of the railroads, logging, mining, and other smaller industries and institutions. By diversifying, it should have a bright future.

One

MOVING ALONG

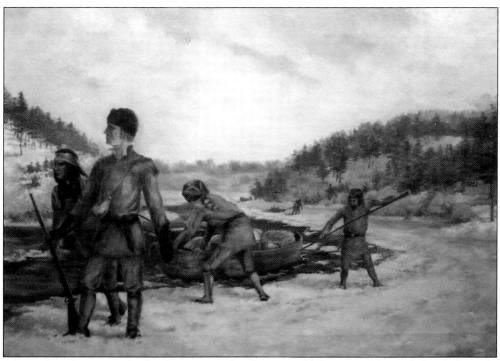

This 1930 oil painting by local artist Sarah Thorp Heald (1881–1954) is titled *Zebulon Pike Exploring the Mississippi River.* Lieutenant Pike, on his exploratory journey up the Mississippi in a 70-foot keelboat searching for the headwaters, spent three days over Christmas 1805 in what would become the Brainerd area.

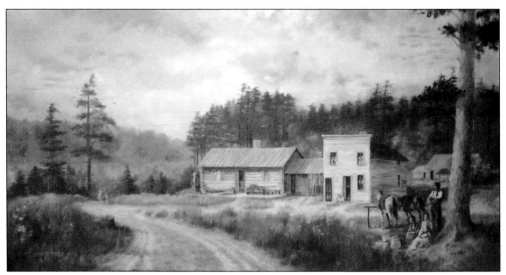

Here is "the Crossing" as it looked in 1870. The town was platted in 1871 with the name Brainerd. The Crossing referred to where the Northern Pacific Railroad crossed the Mississippi River on its way from Duluth to Moorhead. Brainerd was the maiden name of the wife of John Gregory Smith, the president of Northern Pacific Railroad Company. Her father was the former governor of Vermont.

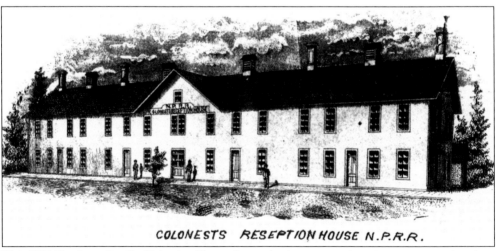

COLONESTS RESEPTION HOUSE N.P.R.R.

This 1872 Northern Pacific Colonists House, for settlers' temporary housing, was a popular place for social events even though it had no running water. It was enlarged to become the Northern Pacific Beneficial Association sanitarium for employee medical care. In January 1883, when it was 40 degrees below zero, there was a fire; luckily, all 35 patients were kept safe. By 1921, the official Northern Pacific Hospital had moved to St. Paul.

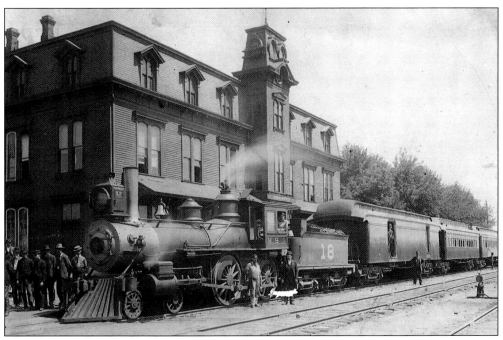

The headquarters of the Northern Pacific Railroad was built on the southeast corner of Main (now Washington) and Sixth Streets in 1872. In 1883, the ground floor became the depot with division offices upstairs. It was destroyed by fire in 1917. Shown with Engine No. 18 are Josiah "Si" Hallett, engineer beside engine; Frank Hitt, baggage man; Newton Paine, drayman; William D. McKay, agent; and Fred Low, bootblack and janitor.

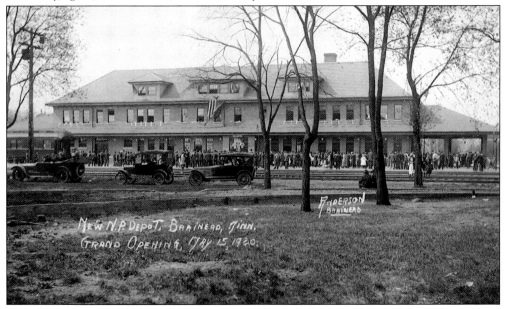

Brainerd's new red brick depot, built just west of the first depot, held its grand opening on May 15, 1920. The second floor held several offices, including those of the Minnesota & International Railroad, a subsidiary of Northern Pacific. Passenger rail service on the Duluth to Staples line was discontinued in the late 1960s, and the depot was demolished in 1968.

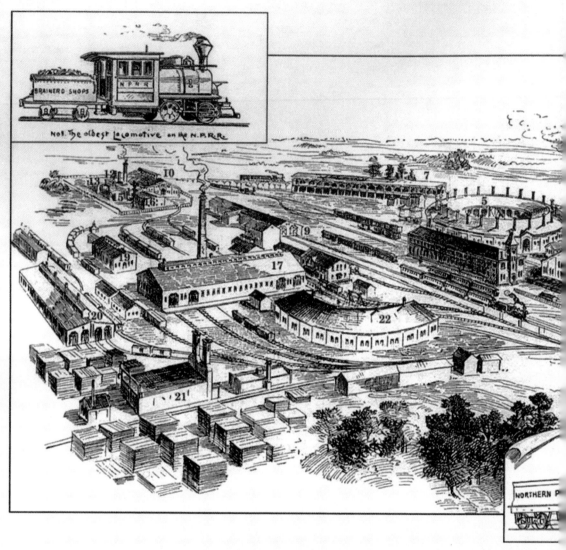

Not The oldest Locomotive on the N.P.R.R.

BRAINERD.--THE NORTHERN PACIFIC RAILROAD SHOPS *(Drawing by John*

KEY TO BUILDINGS

1-General Office Building and Storehouse 42' x 282'
2-Boiler and Tin Shop 80' x 224'
3-Machine and Erecting Shop 120' x 244'
4-Engine and Boiler Annex 40' x 80'
5-Roundhouse 316' in diameter
6-Blacksmith Shop 80' x 197'
7-Iron and Coal Storehouses 26' x 57' and 26' x 98'
8-Oil House 45' x 62'
9-Paint Shop 50' x 200'
10-Foundry 80' x 235'
11-Brass Foundry Annex 16' x 33'

12-Engine and
13-Cleaning Ro
14-Cupola Room
15-Core Rooms
16-Pattern Stor
17-Wood Workin
18-Iron Shop A
19-Office Build
20-Freight Car
21-Lumber Dry
22-First "Round

Key to Buildings Researched and Compiled by Ann M. N

Locomotive of To-day

35]

x 21' x 43'

x 60'
x 160'
5'

80' x 160'
x 70'
t circa 1871

John Passmore drew the Northern Pacific Railroad shops complex in 1885. Using Passmore's drawing, the buildings were numbered and named in a key compiled by Ann M. Nelson, a local historical researcher. Included are drawings of Northern Pacific Railroad Locomotive No. 1 made in 1870 (upper left) and a locomotive from 1885 (lower right).

15

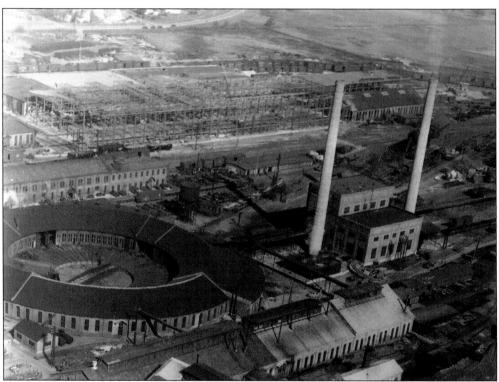

This aerial view of the Northern Pacific shops, looking toward the northeast on October 18, 1945, includes the $1.5 million car shops under construction and the roundhouse. The car shop was 916 feet long and manufactured freight cars. The roundhouse was 316 feet in diameter and contained stalls for 44 engines but was demolished in the 1960s.

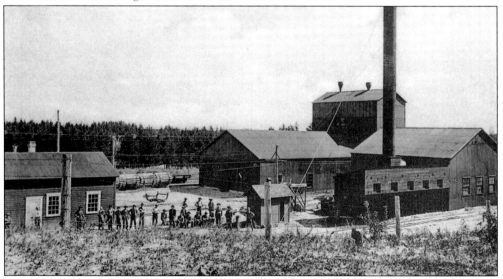

The Northern Pacific Railroad Tie-Preserving Plant was located one mile west of the city on the south side of the tracks in 1907 and enlarged in 1944. Thirty-five to fifty men were employed treating railroad ties with oil and creosote as preservatives. Up to one million ties were stored at the site until it was closed in 1986. (Courtesy of Carl Faust.)

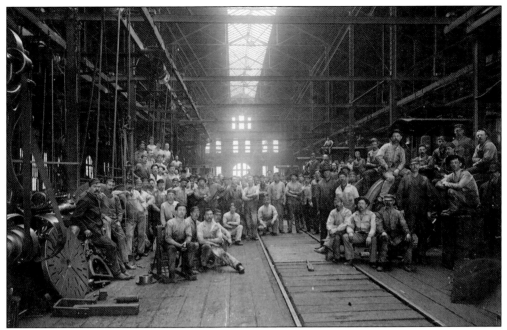

The interior of the Northern Pacific Railroad machine shop is shown in 1893 with a large crew. The machinists were granted a raise in 1899 from 27.5¢ to 29¢ per hour. In 1904, the International Association of Machinists was attempting to have the regular workday changed from ten to nine hours at the same pay.

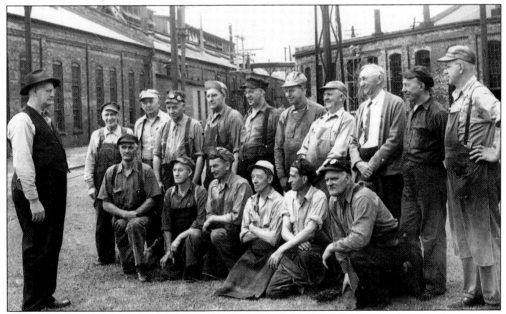

In about 1950, foreman Clarence Benest is shown with blacksmith shop workers; the locomotive roundhouse is behind them. From left to right are (first row) Walter Jacobson, Severn "Red" Antonson, Edwin Olson, Guy Baker, Edward Frayer, and Arthur Finne; (second row) Charles Schrader, August Kalucha, Chris Duneman, Herman Menz, Ole Antonson, Walter Larson, Pontus Anderson, John B. "Tool Dresser" Johnson, William Lease, and Colin Peter.

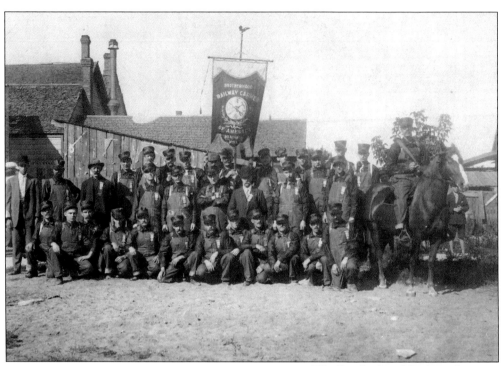

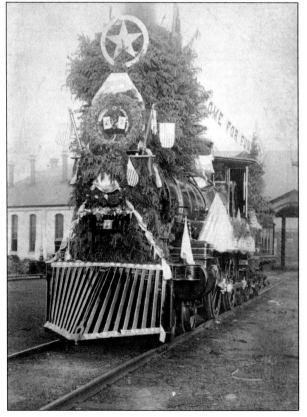

The Brotherhood Railway Carmen of America, a union founded in 1890 by workers who repaired and inspected railroad cars, was photographed after the Brainerd Labor Day parade in 1904. In 1922, 1,250 local shop men walked out as sympathizers in a six-month nationwide rail strike, accompanied by scabbing and fights. When the strike ended, pay dropped from 72¢ to 70¢, blacklisted men lost their jobs, and animosity lasted for years afterward.

Northern Pacific provided annual picnic excursions for its employees and families for several years. In 1885, this locomotive pulled over 900 people on an all-day trip to Detroit (now Detroit Lakes), where they joined with 500 more from Fargo and points west. The people were awakened by cannon fire at 4:00 a.m., enjoyed food, baseball, boat races, and footraces upon arrival, and returned at 10:00 p.m. Later destinations included Perham and Glenwood.

The Villard Hotel was built in 1882 on the northwest corner of Sixth and Main (now Washington) Streets, financed by Charles Kindred and George Hayes. It was named after Henry Villard, president of Northern Pacific Railroad, when the railroad business in Brainerd was really booming. The population in 1881, including transients, was estimated at 14,000. The Villard had financial difficulties and was lost to fire in 1887.

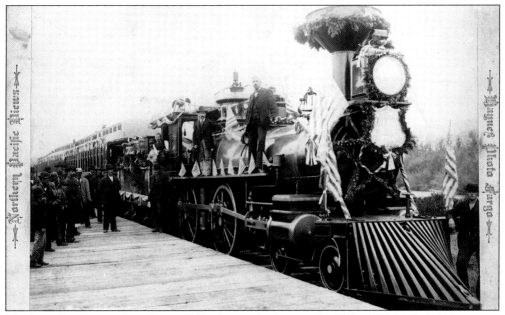

Northern Pacific president Henry Villard invited riders on the Villard "Gold Spike" Excursion, celebrating the opening of the main line from Lake Superior to Portland, Oregon, and Puget Sound. On Saturday, September 8, 1883, when the golden spike was driven in Gold Creek, Montana, Brainerd had an elaborate parade, decorated buildings, speeches, a cannon, and fireworks. Villard and former US president Ulysses S. Grant visited Brainerd on the return trip.

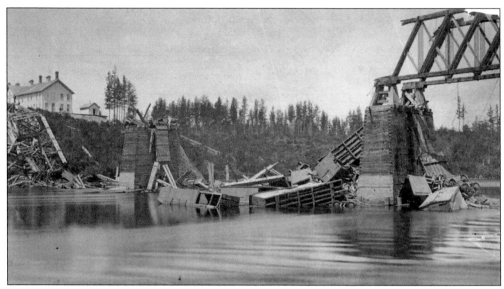

The Northern Pacific Railroad wooden trestle bridge across the Mississippi River was built in 1871. On July 27, 1875, one end of the bridge collapsed under the weight of a freight train. The engineer, fireman, and two passengers were killed, and others were injured. Cars carrying steel rails and merchandise, barrels of pork, and flour littered the river. On the left is Immigration Hall, which later became Northern Pacific Hospital.

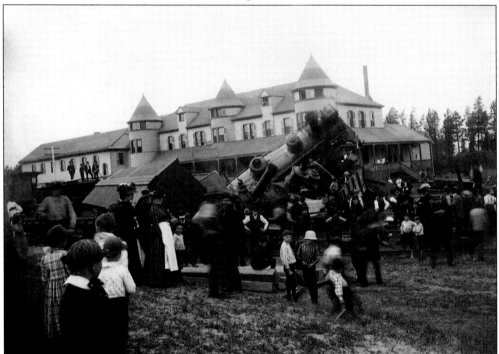

In 1891, freight trains collided in front of the sanitarium just west of the railroad bridge. The engineer, seeing a collision was inevitable, pulled beyond the bridge and succeeded in saving the bridge and all his freight cars. The trainmen all jumped free so there was no loss of life. Track was laid around the wreck within hours so train traffic could continue while the wreck was cleared.

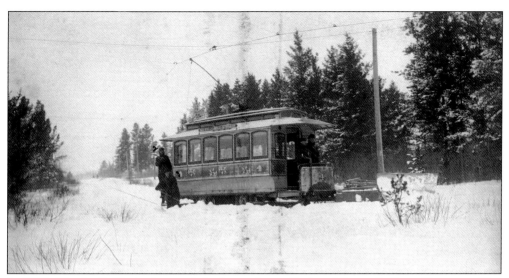

In 1885, Charles F. Kindred started the horse-drawn Brainerd Street Railway Company. The system was 1.5 miles long, starting near Kindred's home. When it crossed the ravine bridge, the horses were limited to a five-mile-per-hour walking speed. Kindred ran into financial troubles and left Brainerd in 1889. Then, in 1895, Charles N. Parker started operating the Brainerd Electric Street Railway Company. He had a car barn, an electricity-generating powerhouse, a private ravine bridge, and four miles of tracks. The 1896 photograph below shows Front Street looking east from Sixth Street with Parker's son, Fred, at the controls. When the 1898 tornado destroyed this bridge, it was the end of Brainerd's streetcars.

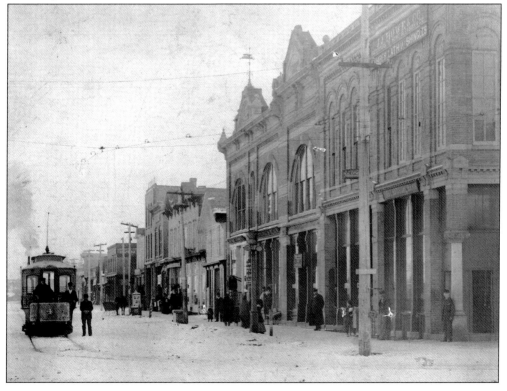

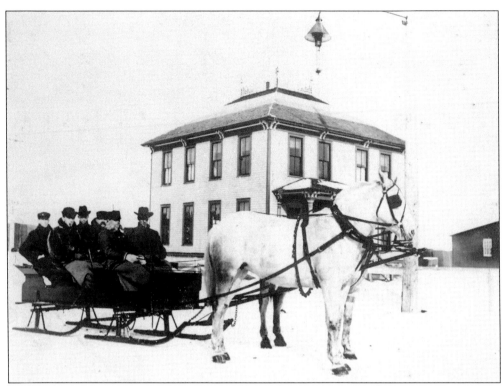

Fred Kaupp held a variety of jobs in Brainerd but, when this photograph was taken in 1903, he was employed as a coachman. What a dapper-looking group of men he has on the sleigh pulled by his team of horses. Unless the white horse has six legs, there is a second horse there.

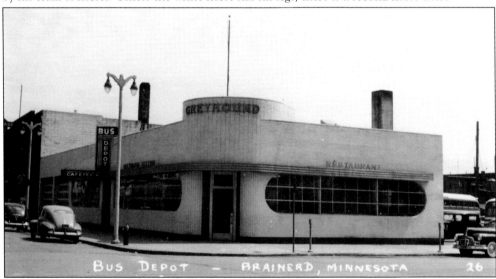

In 1914, the Greyhound Bus Company was founded in Hibbing. Brainerd's location at a major intersection near the middle of Minnesota made it a handy transfer point, but the company used a small café as a depot. In 1945, this modern Greyhound Bus depot with its own restaurant was built on the corner of Fifth and Laurel Streets in Brainerd. It now houses an optometrist and law office.

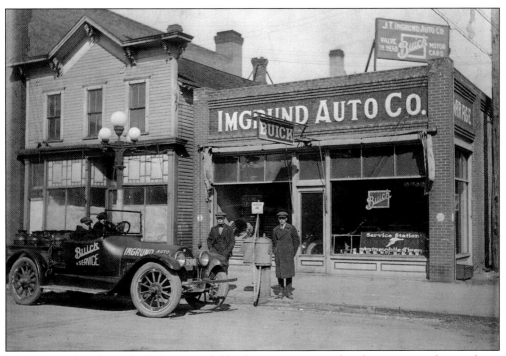

John Imgrund and sons Jack, Louis, and Charles were connected with automotive history here. The first Buick dealer in town was Ezra Smith, and John bought his business in 1916. In those days, cars were not driven in the winter, so the automotive business was seasonal. Note the cream cans in the back of the vehicle. They hold brook trout used to stock Bane Creek.

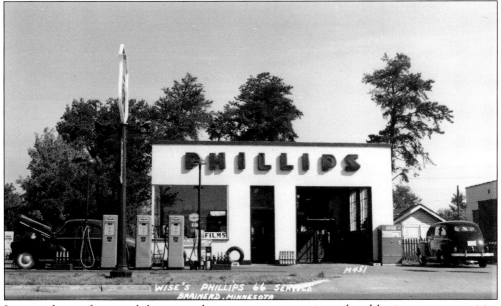

Increased use of automobiles opened up new transportation-related business opportunities everywhere. James Graham opened the first gasoline station in the city of Brainerd in 1922. Before that, automotive repair shops dispensed gasoline from barrels. Pictured here is Frank Wise's Phillips 66 gasoline station at 103 Washington Street in the 1940s or 1950s.

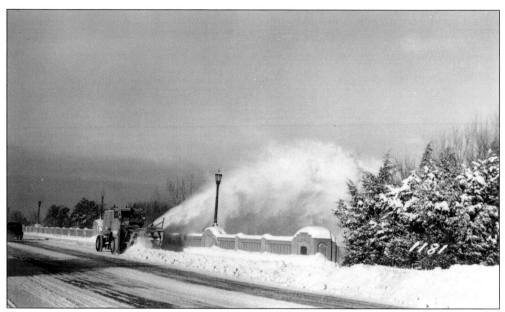

Brainerd's average annual snowfall is over 50 inches. As much as 24 inches has fallen in a single day, sometimes accumulating many feet by the time some storms end. Drifts have been 12 feet high. This old snowplow is on the Washington Street Bridge built over the Mississippi River and ready for travel in 1932. Note the late 1930s model car on the far left. The concrete bridge is located where ferries used to cross the Mississippi River. The photograph below shows the depth of the snow at 915 Laurel Street in a 1950 Brainerd snowstorm.

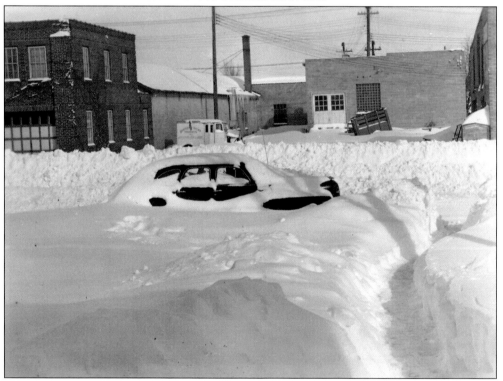

Two

SETTLING DOWN

Christopher Snell was a Civil War veteran
who had been held prisoner in Andersonville
Prison in Georgia for a time. He came
to Brainerd in 1882 and found a job at the
Northern Pacific Railroad shops, building doors
for train cars. He died at his east Brainerd home
in 1909.

Townsite agent Lyman P. White came here by stagecoach at age 60 in 1870 and became known as "Brainerd's First Citizen" and "Father of Brainerd." He platted the town and sold lots to new residents. White was Brainerd's second mayor. Over the next 30 years, he was involved in many areas of Brainerd development. He served on the first school board; was on the board of trade; was city treasurer; ran a small sawmill; built the first Crow Wing County jailhouse (at a cost of $971.60), which eventually became Brainerd's first city jail; and helped to secure land for St. Paul's Episcopal Church—where his wife Jennie led the singing. He built his frame home of lumber, not logs, on the southwest corner of Fourth and Juniper Streets. He died at age 92 and is buried in Evergreen Cemetery.

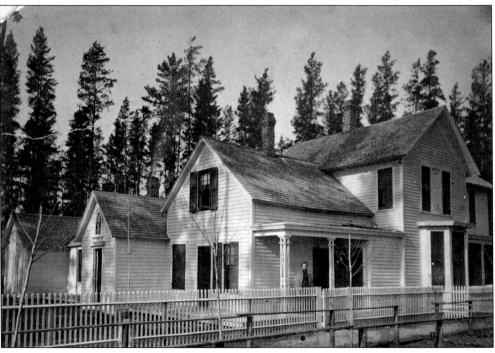

Ernest Jones was born in October 1873, the 42nd baby to be born in the city of Brainerd. His wife, Sophie, was head clerk at L.M. Koop Dry Goods before she and Ernest opened their own dry goods store with Sophie in charge. It was successful, and in 1915, about the time this family photograph was taken, they moved it to 614 Front Street. They had two children, Henry and Margaret. Henry, known as "Bubs," seen below in his basketball uniform, graduated from Brainerd High School in 1923. He entered the US Coast Guard Academy but, in 1927, was lost at sea. He was the first Coast Guard cadet to die while on active duty. The Cadet Memorial Field in Connecticut was originally called Jones Field in his memory. Now, it honors all cadets who have died.

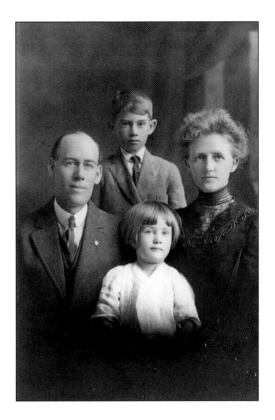

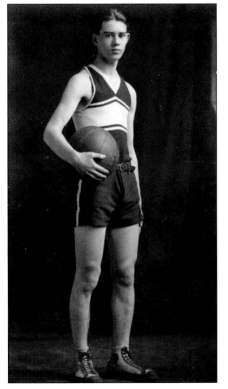

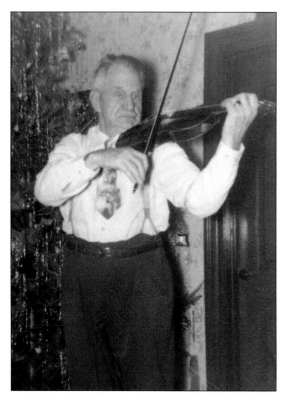

Olaf Alexander Olsen was born in Norway in 1878. While in the Norwegian army, his last name was changed to Ness. He became a US citizen in 1935 while living in Brainerd. He worked as a machinist for the Northern Pacific Railway from 1939 to 1946, when he retired. One would hope that he had many happy hours playing his fiddle until he died in 1956.

Silas Hall came to Brainerd in 1879 and stayed for 57 years. He not only homesteaded 160 acres southeast of Brainerd but also lived in town at 209 North Fifth Street. He was a conductor for the Northern Pacific Railroad until he went into the drayage business, first with horses and wagons, and later with trucks. His son Roy worked with him and took over the business in 1924.

Abraham Lincoln Hoffman (son of Baron Von Hoffman, inventor of compressed yeast) moved to Brainerd in 1884. He stayed until his death in 1926 in his home at 216 North Fifth Street. He ran a mercantile on the corner of Laurel and South Sixth Streets. He belonged to various lodges, was secretary-treasurer of the Brainerd Board of Trade for 25 years, and served as municipal judge for four years.

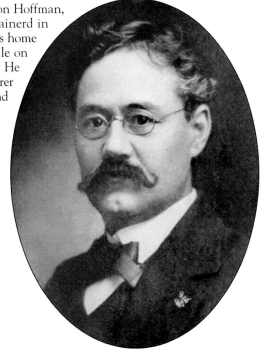

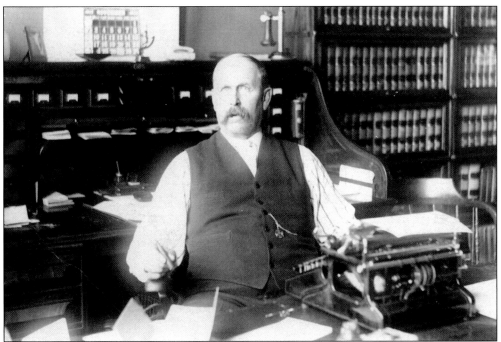

Judge J.T. "Tom" Sanborn came to Brainerd around 1880. In 1892, this quiet, kind man was elected alderman, but set his sights on becoming probate judge. After his third campaign, he won the coveted seat and took office January 1, 1903. After working all morning September 25, 1923, Sanborn went home to Juniper Street for his lunch. He complained of chest pain and was dead by 12:30 p.m.

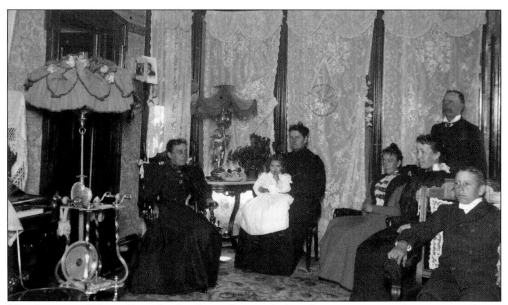

The George and Emma Forsythe family was known for lavish entertaining in their spacious home in northeast Brainerd. George was a foreman at the Northern Pacific Railroad shops. Emma, sometimes called "founder of northeast Brainerd," was involved in real estate, at one time owning 200 houses in northeast Brainerd. She represented the region at the 1893 Chicago World's Fair. She maintained a private livery of thoroughbred horses.

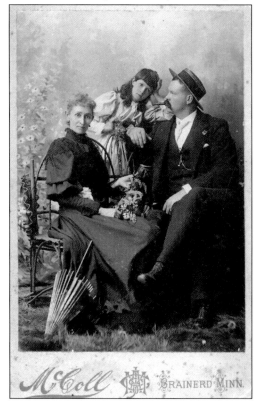

John and Jennie McColl are pictured with their daughter, Islay, in their garden at 218 North Seventh Street. In 1881, John started a photography studio, which he eventually sold. They went into the candy, cigar, soda fountain, ice cream, and novelty business on Sixth Street. Islay grew up to be an author as well as deputy treasurer for Crow Wing County. She resigned after 24 years to work with her husband in advertising.

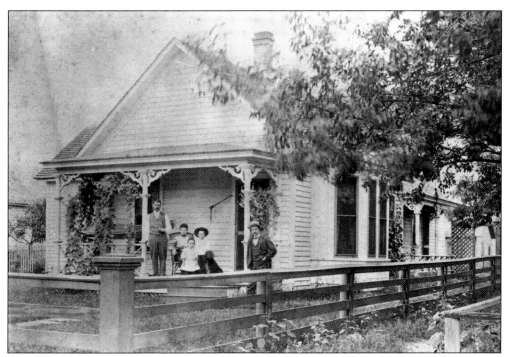

David Kennedy Fullerton came to Brainerd in 1881. He and his wife, Sarah, lived in this home at 502 North Ninth Street. He was a builder (remembered for building the Methodist church) and a foreman for Northern Pacific Railroad. From left to right in this 1897 photograph are David, Sarah, their sons Harry and Fergus, and Sarah's brother-in-law William Webb Smythe.

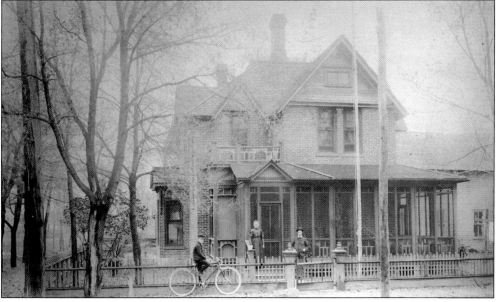

From left to right are Frank Ferris (born 1889) on the bicycle, Frank's grandmother Beulah Ferris, and Clifton Allbright at the Ferris home at 601 Kingwood Street. Frank was the son of Allen and Anna Ferris. After they divorced, Allen married Helen Nelson. He lived only another year. After his death, Helen married Warren William, the Aitkin-born Hollywood movie star.

Sarah "Sadie" Reilly Dunn moved to Brainerd as a child with her family in 1882. In 1904, she married Henry Paul Dunn, a civic-minded pharmacist who also did service as postmaster and mayor. Shown here are photographs of each. Sadie was a member of the Ladies Auxiliary of the Ancient Order of Hibernians and a member and officer of the Women's Relief Corps. She was on the National Board of Catholic Foresters and, during World War I, instructed Red Cross workers. Much of this activity was after she was struck with a severe case of arthritis in 1921. She was often confined to her bed until her death in 1932 at age 59.

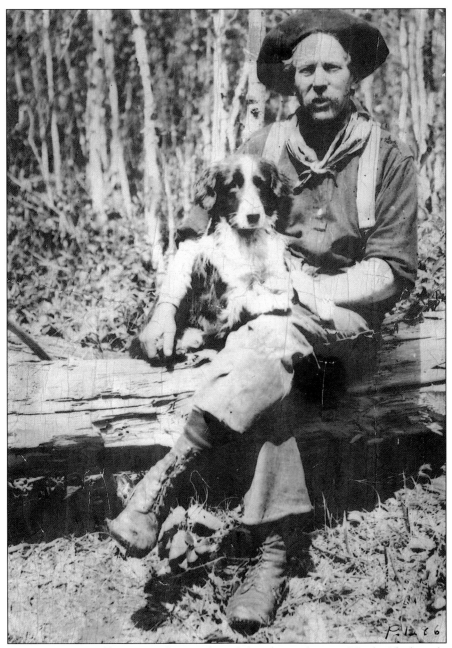

Ora M. Smart was usually seen in the woods with his dog and a gun. Uncle Aleck, as he was called, made his living by hunting, trapping, logging, farming, surveying, canoe portaging, and more. He was considered an authority on game animals. He was a fiddler, a philosopher, and a poet. At the time of his death in 1946, he had lived in Brainerd for 22 years in his hand-built cottage at 704 Third Street South on the west end of Pine Street. The third and fourth stanzas from his poem "The Lone Trail Man" read: "I snuggle up tight by my campfire bright / And I stare at the rising moon; /As the embers die I hear the cry / Of the wakeful blackthroat loon. / Lonesome, you say? To some it may / Seem a bit that way, but I / Get a sort of cheer from the high notes clear / Of its weird and mournful cry."

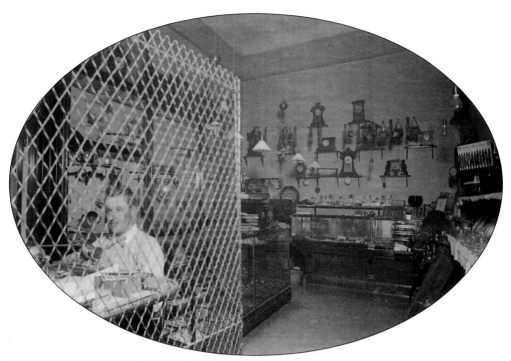

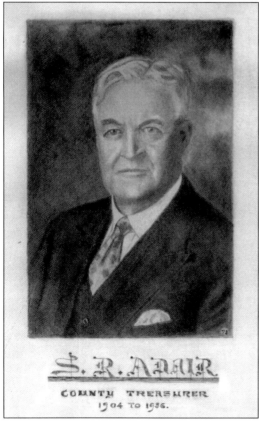

S. R. ADAIR
COUNTY TREASURER
1904 TO 1936.

When master watchmaker Samuel R. Adair came to Brainerd in 1886, he went to work at Circle Front Jewelry Store (on Sixth Street between Front and Laurel Streets), named for its circular display window. He remained in the jewelry business until he was elected county treasurer in 1903, a position he held until his death in 1936. He married Alice Nolan in 1892. Adair was active in local affairs, serving as a captain in the National Guard, president of the Crow Wing County Historical Society, and president of the Brainerd Building and Loan Association. He was also active in several other civic organizations. He was president of the Brainerd Automobile Club and active in the local bicycle club. Once, he rode his bicycle over the sandy roads all the way to Minneapolis (and back) just to watch a baseball game.

Three

LEARNING AND
WORSHIPPING

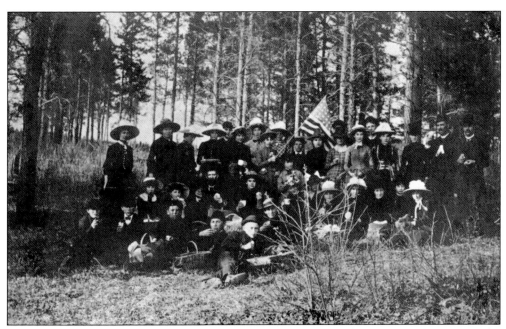

This 1886 Brainerd High School class is on a May Day outing near the Mississippi River. Note the American flag, the hats, and the picnic baskets. Some of the boys apparently did not want to stop eating, even for the posing of this photograph. Brainerd, as well as the whole state of Minnesota, has always enjoyed a reputation for quality educational opportunities.

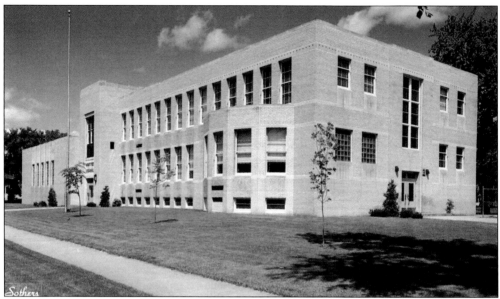

Late in 1872, the state legislature authorized Brainerd to form an independent school district. In January 1874, the first public school opened. It was a two-room frame building on the northeast corner of South Sixth and Oak Streets. It became known as the Sixth Street School. Later, additions to the building were necessary to accommodate a growing student population. As the community continued to grow, the school system also needed to grow. The year 1893 saw a big building boom for schools. That year, there were four new grade schools erected, using bricks made on the east side of Brainerd's Rice Lake. In 1939, all four of the 1893 schools were replaced with larger, more modern structures while retaining their original names. The 1939 Whittier (above) and Harrison (below) schools cost $450,391 to construct both buildings.

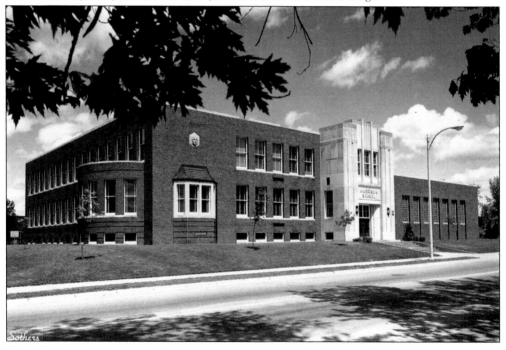

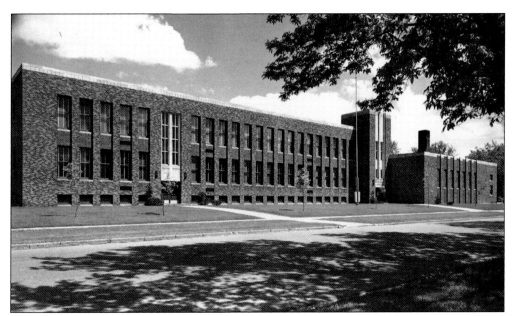

Also replacing 1893 buildings that had become inadequate were the 1939 Lowell (above) and Lincoln (below) schools. In 1938, a bid of $267,771 to build these two schools was approved. By the time construction was completed, an additional $70,000 was needed and was approved because the cost of materials had gone up since the Public Works Administration had applied for the funds. Earlier, with the student population still increasing, the school board decided that more elementary schools should be built. Riverside in 1919 and Garfield in 1921 helped to relieve crowding at the four existing schools. Kindergarten was authorized in 1934.

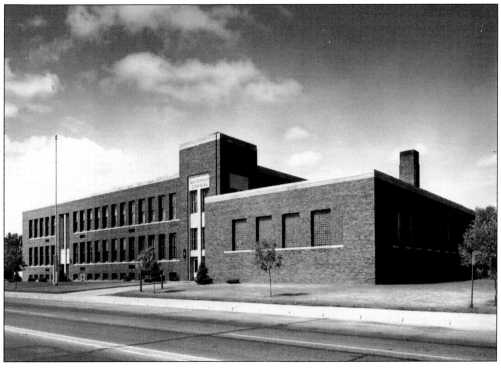

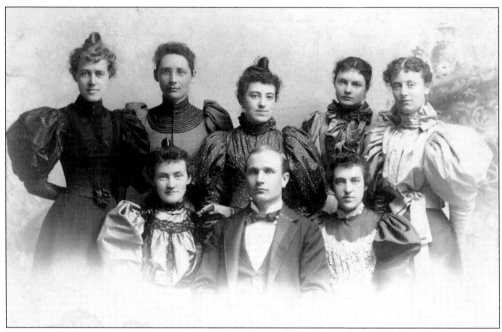

Some of the faculty members of the Brainerd school district look distinguished around 1898. In the first row on the left is Emily Murphy. Teacher Amy Lowey (second row, second from left) later became the headmistress of the St. Mary's School for Girls in Fairbault. The gentleman is Prof. T.B. Hartley, who served as superintendent during 1898–1900 and 1902–1909.

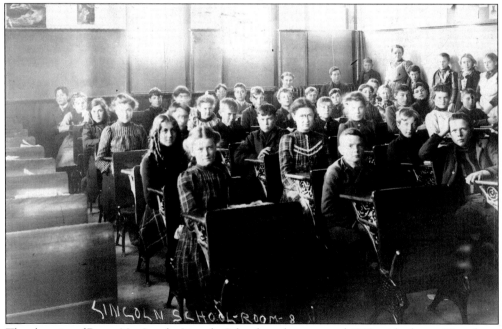

The class size of Room No. 8 at the Lincoln School was large around 1903, with almost 40 students being taught by Margaret Carr. Although the four elementary schools were only 10 years old at the time, classes were still being held in places other than the schools, most likely because of overcrowding. The four replacement school buildings were still 36 years away from being built.

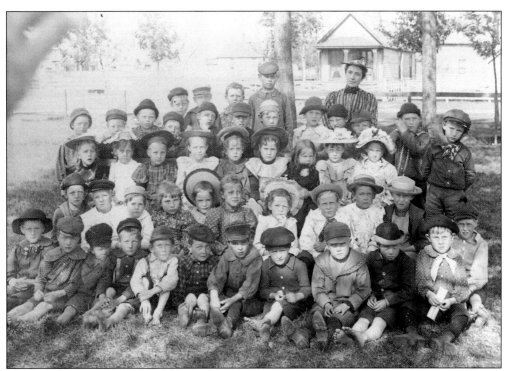

Hats and caps were certainly in fashion around 1896 for this first-grade class at the Harrison School, but note that two-thirds of the pupils in the front row are not wearing shoes. This group must have been a handful with 47 students and only one teacher, Ida Peterson.

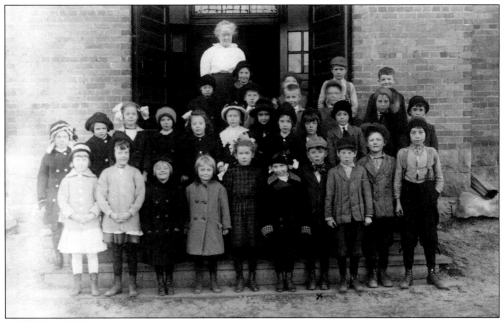

With many looking like they were dressed up in their Sunday best, this mostly somber-looking group of 30 students lined up in front of the Whittier School in 1914. Keeping an eye on them was their teacher Bessie Mulrine. Never married, she passed away only six years later at age 52.

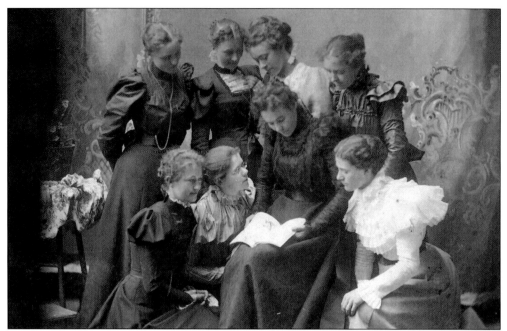

In order for the young children of Brainerd to learn, they needed people to teach and guide them. That was the responsibility of these ladies at the Lowell School in 1898. From left to right are (kneeling) ? Miller, Lu White, and Rose Arnold; (sitting) ? Summers; (standing) ? Paine, Lena Mix, Bella McKay, and Nellie Merritt.

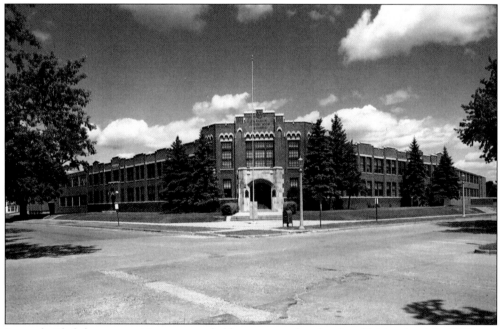

It was decided that a transition was needed between grade school and high school. In 1931, at a cost of $244,000, construction started on the Franklin Junior High School. It opened its doors in September 1932 to seventh-, eighth-, and ninth-grade students. An addition was put on in 1955. Located at Tenth and Kingwood Streets, it would be used until 2005.

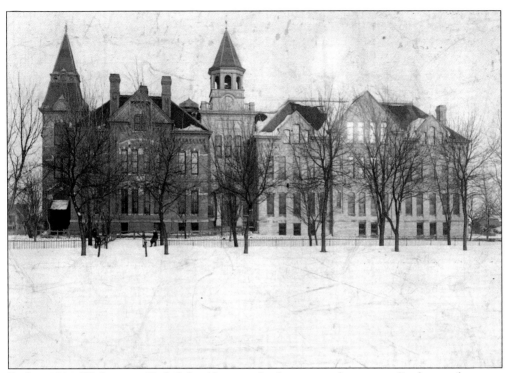

Built in 1884, Washington High School became the first one in the county. Graduates of country grade schools who desired to continue their education had to board in or near Brainerd throughout the school year. Located on the corner of Eighth and Oak Streets, it was an impressive building in this small town. The high school served the community well until the night in March 1928 when a fire destroyed it. The school was closed, as the students had just started their Easter vacation. During the following week, the school board was able to make arrangements for classes to be held on the second floor of the Brainerd City Hall as well as in the older Methodist church at Sixth and Juniper Streets.

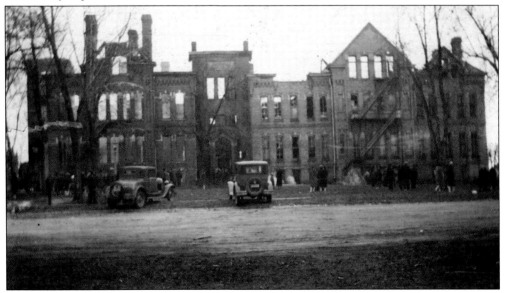

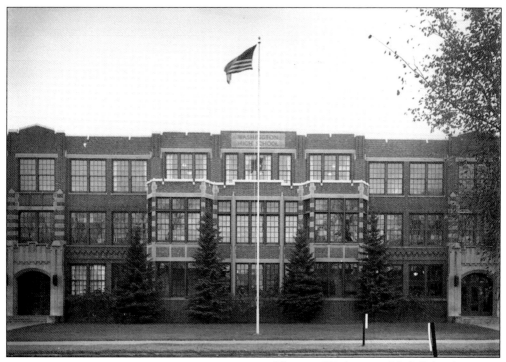

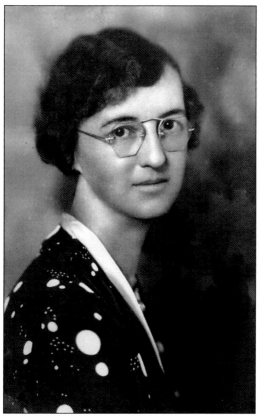

The new Washington High School was built in 1929 and used until 1968, when a new high school building opened. Later, it became the Washington Middle School. Mary Tornstrom came to Brainerd in 1915 as a young woman in her 20s. At Washington High School in Brainerd, she taught German, was a guidance director, served as principal for 34 years, directed plays, and was named dean of women when the Brainerd Junior College had classrooms at the high school. She became active in civic circles as a charter member of Zonta Club, in the League of Women Voters, and a member and Sunday school teacher at the Congregational church. Even after she retired, she continued to teach homebound students. Tornstrom Auditorium is named in her honor.

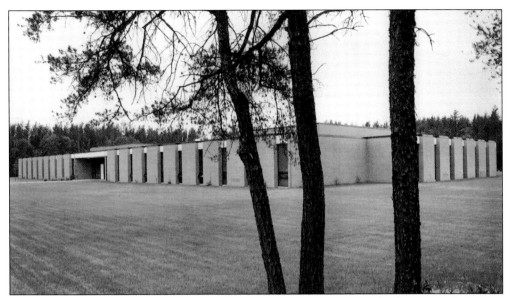

There have been different commercial and business colleges in Brainerd. The Brainerd Business College was located on the old Columbia Block in the Koop Building at 219 ½ South Sixth Street, but the building burned down in 1909. The Brainerd Commercial College started in 1915 on the third floor of the Iron Exchange Building at Sixth and Laurel Streets and, later, moved to the second floor of the city hall building. Thirty students graduated in June 1918. In 1938, the Brainerd Junior College was established. Classes were held on the second floor of Washington High School, and later at the Lincoln School. Eventually, it had its own campus. Shown here are two views of the junior college, now known as Central Lakes College.

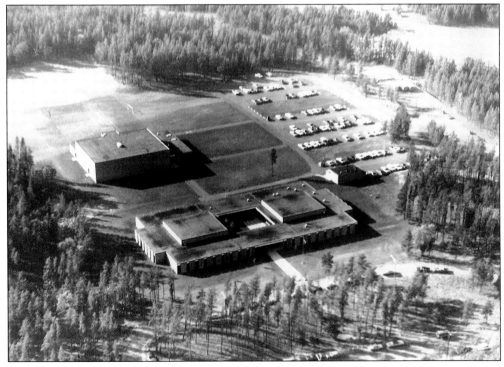

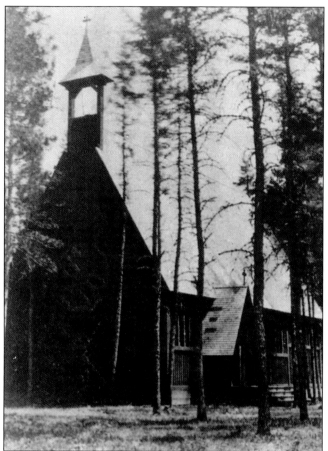

Brainerd has had many monikers—"City of Pines," "City of Homes," "City of Saloons," and ironically, considering that last one, "City of Churches." Brainerd became a city in 1871 and had five churches organized by 1872. These were St. Paul's Episcopal, St. Francis of Assisi Catholic, First Congregational, First Baptist, and First Methodist. The first Episcopal church service in Brainerd was held in 1870. Their first church building was not yet completed when Brainerd's first church wedding ceremony was held there. The groom, Thomas Shoaff, joked that he was the first janitor because he had to clean up the carpenter shavings before the marriage service. His bride was Nellie Lytle, and a locomotive headlight provided lighting for their wedding. The 1872 church is pictured at left.

ST. PAULS EPISCOPAL CHURCH - BRAINERD, MINN. 21

Brainerd's Catholic church on South Fifth Street was established and named by Father Francis Joseph Buh for the saint of peace and brotherly love. After this church was destroyed by fire, property was bought on North Ninth Street where St. Francis of Assisi Catholic Church stands today. That church burned in 1933, after which the current church was built. Father Edward J. Lawlor (pastor here from 1890 to 1892) is shown below with two altar boys. In 1894, Father Lawlor was the priest in Hinckley at the time of the devastating fire there that killed over 400 people. He saved others by gathering them into a body of water, from which they emerged the next morning temporarily blinded by the extreme heat. He suffered lung damage from smoke inhalation and never fully recovered, dying in 1899.

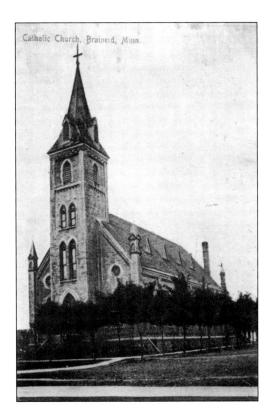

Catholic Church, Brainerd, Minn.

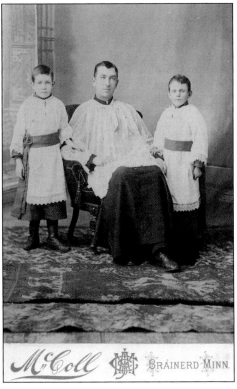

McColl BRAINERD MINN.

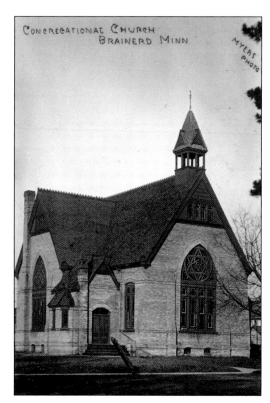

The first building for the First Congregational Church was a gift from Northern Pacific Railroad president John Gregory Smith in 1872. He also gifted them a pipe organ. The building burned down in 1881 and was replaced later that year. The church property was landscaped in 1915 when North Fifth Street was paved. Located at 403 North Fifth Street, it has been remodeled over the years. One of the many ministers of the church over the years was Rev. George Philip Sheridan, who served the congregation from 1911 to 1918. On May 1, 1917, he had the privilege of presiding over the marriage of his sister Ina to Daniel Whitney, an undertaker and licensed embalmer in Brainerd.

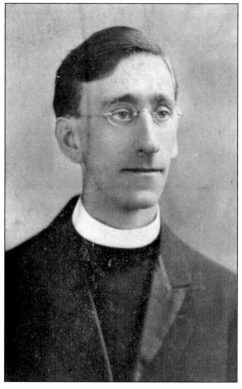

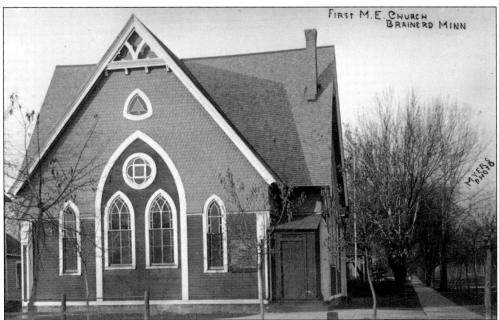

First M.E. Church
Brainerd Minn

Seated on wooden planks balanced atop beer kegs, a group of Methodists met to organize a congregation in a downtown dance hall in October 1872. By late November, a chapel was built. Around 1915, the church moved to the corner of Sixth and Juniper Streets and was called the Methodist Episcopal Church. One of the pastors, Charles Treglawny, was educated in England. He was appointed pastor in March 1890 but got sick and died in 1893. One of his daughters, Elizabeth Fleener, eventually was city clerk in Brainerd for 14 years. The church is now called Park United Methodist.

In 1890, the Norwegian-Danish Lutheran church was organized. It was in 1894 that Pastor Dorothous J. Growe accepted the call to Brainerd. On July 3, 1903, lightning struck the church and it burned, but the congregation finished a new building in time for services on Christmas Day. In 1932, the name was changed to Trinity Lutheran Church. Their current church, built in the 1950s, is located on South Sixth Street.

The local chapter of the Salvation Army began in Brainerd in 1891, initially meeting in a rented storefront. After a night spent in prayer, the next morning they found an envelope containing $900, allowing them to buy an old saloon building for their meeting place. This photograph shows Salvation Army members in the early 1900s.

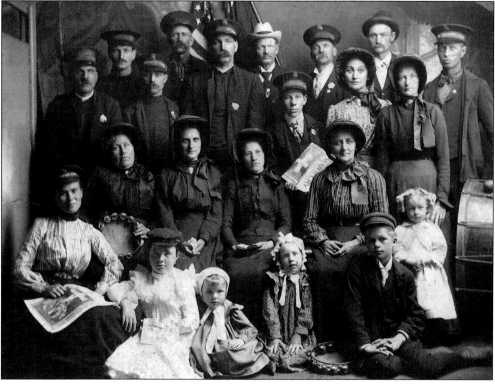

Four

BUYING AND SELLING

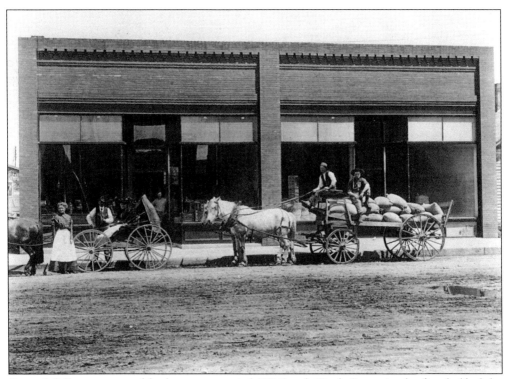

Several different types of feed stores occupied 315 South Sixth Street in the first half of the 20th century. Merchandise sold included animal feed, flour, fuel, lime, salt, baled hay, and more. Merchant names included Daniel Smith, John Larson, the Thabes brothers, the Turcotte brothers, and Abraham Lincoln Hoffman.

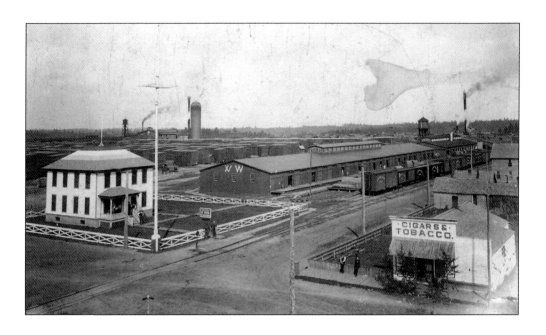

The square white building on the left (with the "Positively No Smoking" sign) is the original office for the Brainerd Lumber Company and sawmill. They sawed logs, planed boards, made shingles and laths, and shipped their products by rail. As the company grew, it moved to Mill Avenue in northeast Brainerd. This office building that had been built in 1890 was then moved to the northeast corner of Sixth and Main (now Washington) Streets in 1908 to become the Northern Pacific lunchroom. In 1924, it became Van's Lunchroom, then Van's Café in 1927; since 1981, the restaurant has been called the Sawmill Inn. It is obvious by looking at both photographs that over the years it has been remodeled and expanded.

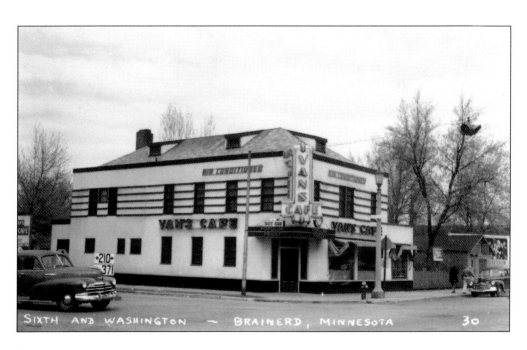

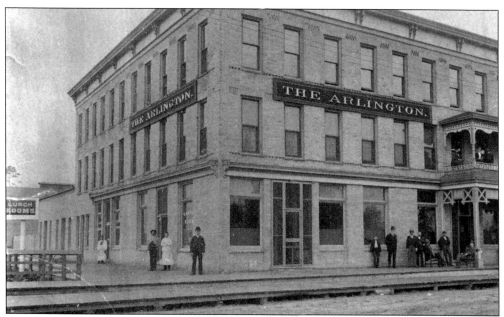

Ransford R. Wise first built the immense Arlington Hotel in Minnewaukan, North Dakota. In 1888, when the cost of liquor licensing got steep, Wise dismantled all but one corner and then transported the pieces by train to Brainerd without one piece getting broken. He reassembled it on the southwest corner of Sixth and Main (now Washington) Streets. The Arlington, considered Brainerd's most splendid hotel, burned down on New Year's Day 1904.

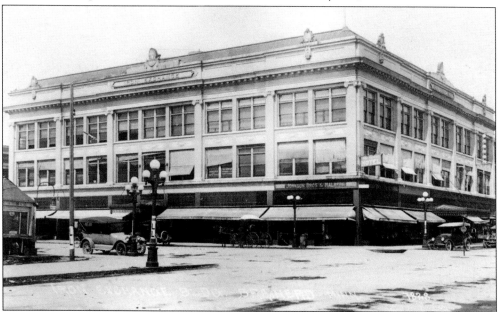

The Iron Exchange Building, built by local men, was ready for occupancy in 1911. This photograph was taken before the streets were paved in the 1920s. The building contained shops, meeting rooms, office space, hotels, a business college, restaurants, and more before it burned down in 1970. Located on the northwest corner of Sixth and Laurel Streets, its name was symbolic of the "new" industrial era.

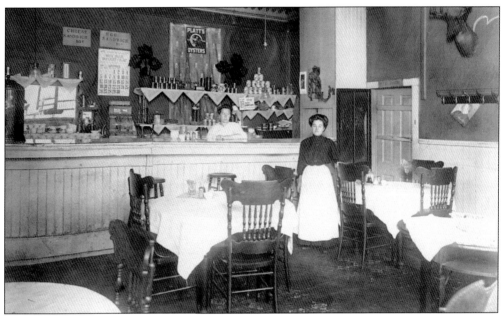

George West was proprietor of the Golden Horseshoe Saloon and Restaurant from 1893 until it burned in 1909. Here is the "new" Horseshoe Café and Bar in the Iron Exchange Building. Nicholas Lauer and his wife Lena, who was also the cook (behind the counter), operated it. Lena often prepared wild game but was renowned for planked fish. By 1919, George West's wife, Edna, managed the West Café in this location.

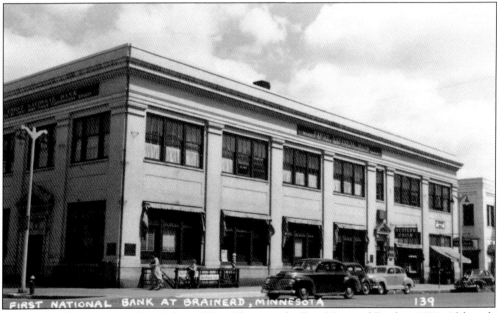

The Bank of Brainerd was founded in 1879 and became the First National Bank in 1881. Although it has been remodeled and has had its facade changed several times, one can still see its name in gold at the top of the building on the southeast corner of Sixth and Front Streets. In 1933, Baby Face Nelson and his gang, with their weapons including machine guns, robbed $32,000 from this bank.

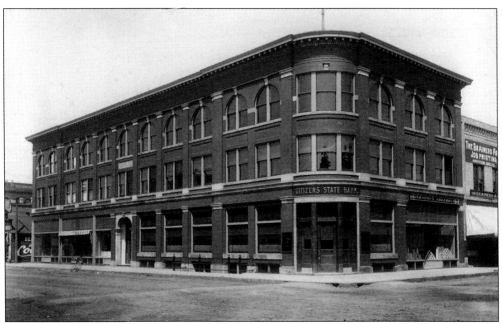

The second bank in Brainerd, the Northern Pacific Bank, was organized in 1889. It became the Citizens State Bank in 1906. The three-story structure is located on the corner of Seventh and Laurel Streets. There were four vaults and 200 safety deposit boxes. The second floor was divided into 18 office suites, each with a lavatory. They boasted electric lights and lavatories with hot and cold water. It contained the first elevator in town. The Knights of Pythias leased the third floor. As depicted in the interior view below, it was elegantly finished with mahogany and imported Grecian marble.

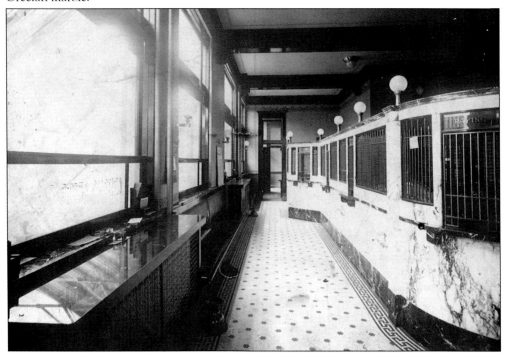

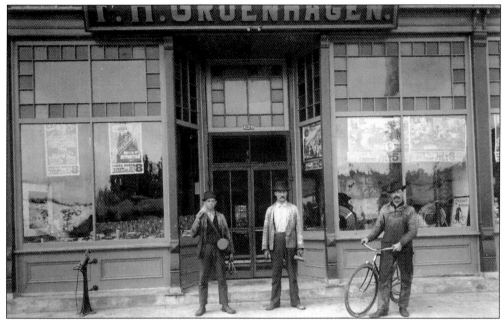

Fred H. Gruenhagen was born in 1870 and moved to Brainerd in 1889. For 11 years, he was a tinner for Slipp Brothers. He then went into business for himself, eventually building the Gruenhagen block and moving his business there. It stayed at 217 South Seventh Street for many years. Types of merchandise advertised over the years included plumbing, heating, bicycles, furniture, and farm machinery, as well as hardware.

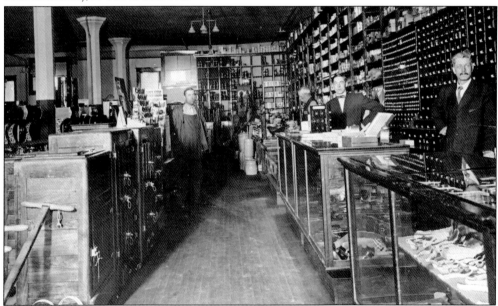

D.M. Clark and Company dealt in furniture, hardware, plumbing, heating, and funerals. Fire destroyed the business in 1909; within a month, the undertaking department reopened. Shown from left to right are Julius Deering, a tinsmith; Daniel M. Clark, who retired in 1923 after 40 years; Daniel's son Robert, a buyer, who died at age 23 in 1914 from tonsillitis; and Thomas Gibson, coroner, who died in 1912 at age 47 from a tumor.

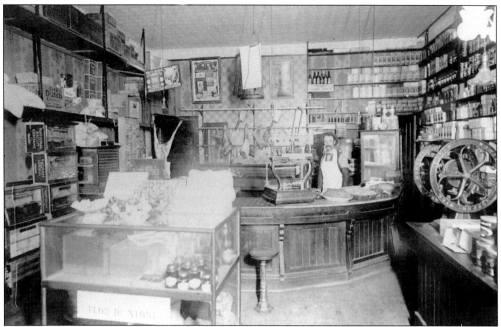

Here is Henry McGinn behind the counter at Paine & McGinn Meat Market at 219 South Sixth Street. McGinn worked in the grocery and meat business in Brainerd for about 35 years. His son, also Henry McGinn, became a veterinarian. Charles "Howard" Paine was associated with McGinn in the meat market; in 1926, he retired to become a "gentleman of leisure."

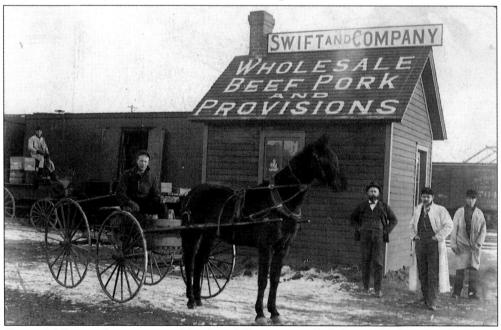

Casper Mills was the manager of Swift and Company at Eighth and Washington Streets in Brainerd. Two of the salesmen were Fritz Hagberg and his nephew Arthur Hagberg Jr. Fritz (born in 1881) was also a mill clerk, county auditor, city treasurer, and a member of the school board. Arthur (born in 1896) also worked for the Crow Wing County Oil Company.

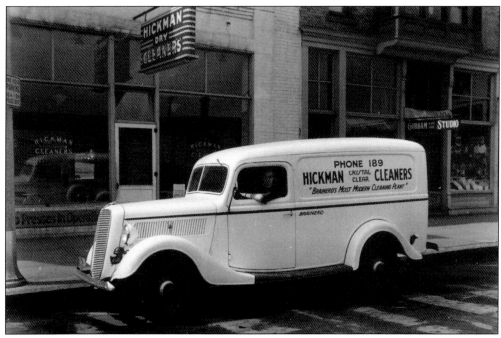

In 1904, a Chinese hand laundry business was on South Fifth Street. Soon there were more clothes-cleaning establishments. In 1920, Anderson Cleaners started on Laurel Street; the business is still in the Anderson family. In 1937, Hickman Crystal Clear Cleaners was located at 719 Front Street. Note the "189" telephone number on the delivery van.

Deering Manufacturing Company made and sold motor vehicle parts and accessories. Julius Deering; his wife, Alma Gail; and his sister Caroline started the business. Julius Deering, a Brainerd tinsmith, invented and patented an under-the-front-seat spring for Ford cars and trucks. It elevated the seat and gave a smoother ride. Deering, seen here in northeast Brainerd, died in 1936.

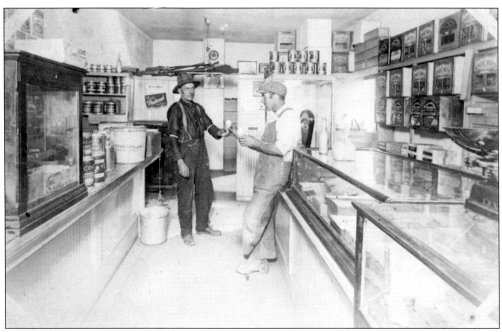

Both of these grocery stores were located at 910 Oak Street. In the 1910 photograph above, it was the J.B. Swisher Grocery Store and was owned by Jonathan B. Swisher, a Civil War veteran for the Union army. (He was one of many soldiers of that era who had to lie about their age to get admitted.) By the time of the 1927 photograph below it was the Dye Grocery Store. Ada Dye (who never married) and her brother Judson are pictured. They were siblings of Jonathan Swisher's wife, Florence. By that time, Swisher, widowed, was retired and lived at 911 Oak Street.

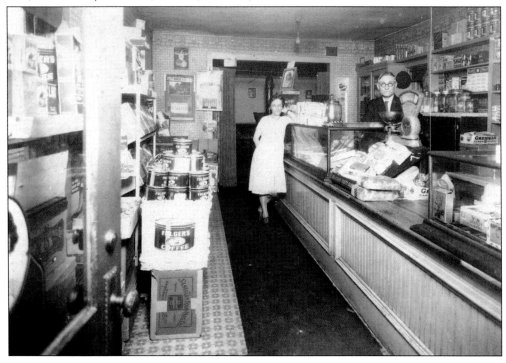

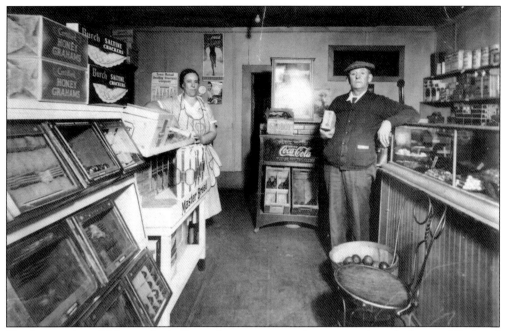

Confectioneries, which were basically candy stores, were quite common in early days, and Brainerd was no exception to that trend. Harold Whitlock's Confectionery was located at 1518 Oak Street. This 1938 photograph shows clerk Clara Headman and a customer. Clara's sister Lillian was married to Harold Whitlock, owner of the store.

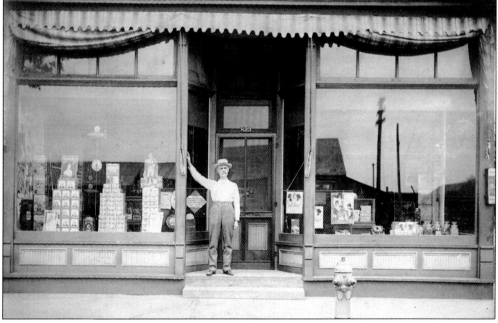

Alphonse J. Drapeau and his wife, Mary, came to Brainerd about 1889. They ran the Winsor Hotel for a number of years before starting a confectionery at 823 Main (now Washington) Street in their home. Here is their shop as it looked in 1910. They sold groceries and cigars and also had an ice cream parlor.

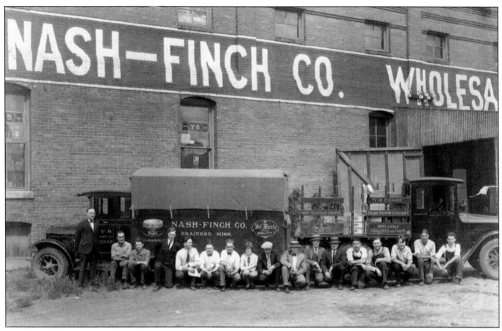

Both "Nash" and "Our Family" were memorable brands made by the Nash-Finch Company, a Midwestern wholesale grocery distributor. In 1924, Nash-Finch bought out Brainerd Wholesale Grocery Company, which was established in 1901 and located at Fourth and Front Streets. Marshall W. Pierce was the manager in 1927. The Nash-Finch Company in Brainerd closed in 1984.

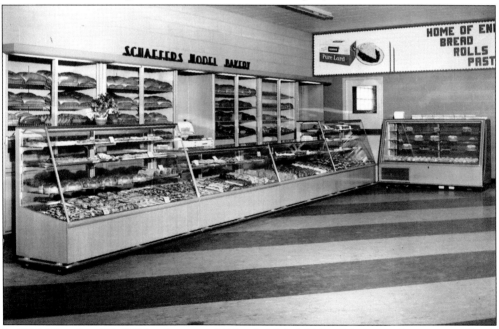

In 1914, Theodore "Ted" Schaefer opened Schaefer's Model Meat Market at the corner of South Sixth and Maple Streets. Surprisingly, in 1955, two of his sons opened another grocery store only a block away at the corner of South Seventh and Maple Streets. Note the sign for lard. The Schaefer family is still in the grocery business at a different area location.

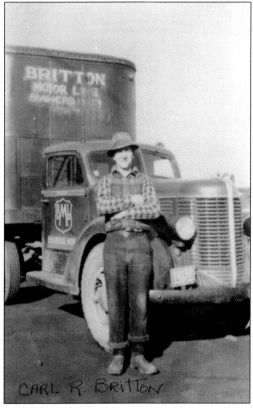

CARL R. BRITTON

John Britton moved to Brainerd with his family by covered wagon in 1881. By 1900, they had built a family home on the north side of East Oak Street, which was continuously occupied by four generations of Brittons. First were John and Julia, next were Jess and Cleo, and then Carl and Mabel with their children Bennie, Irene, Elaine, and Shirley. John, of the first generation, was a drayman, and his wife, Julia, was a schoolteacher. Jess and Cleo were farmers. Carl, of the third generation, is shown in the 1936 photograph at left near the family truck used to haul cattle, pigs, and more for the family farm located east of the home.

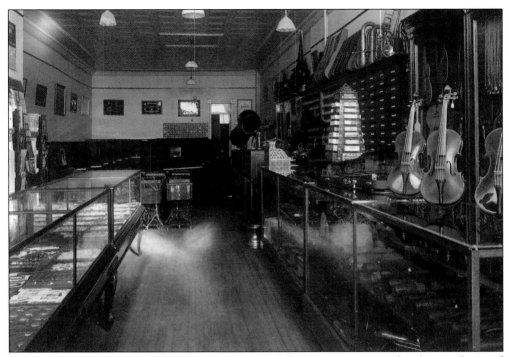

Folsom Music Company, established in 1898 at Little Falls, Minnesota, opened its doors in Brainerd at 212 South Seventh Street in 1914. Walter Folsom had attended a musical conservatory and was considered a talented musician. By 1926, Walter Folsom and his son Lee were also selling radios and appliances. Folsom Music Company remained open until 1966.

This 1938 photograph shows, from left to right, Waldo Trask, John Arnold, Alvin Arnold, and Howard Zander in the Arnold Mercantile Company at the corner of Fourth Avenue and C Street in northeast Brainerd. The store building was originally a schoolhouse that John Arnold's father remodeled into the grocery store in 1902.

Some say that the best Coney Island sandwiches in Brainerd were served in the Broadway Lunch restaurant at 213 South Eighth Street, owned by Greek native John Vemos, known as "Broadway Johnny." That makes sense because these hot dog, chili, chopped onion, and mustard concoctions were associated with Greek food.

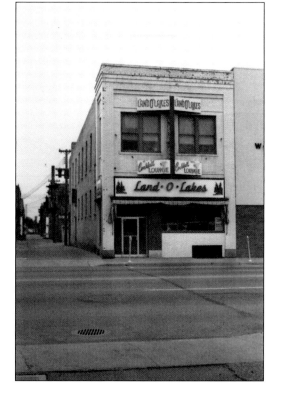

Land O' Lakes Café and Cocktail Lounge was located on the east side of South Sixth Street between Front and Laurel Streets, next to the Brainerd Dispatch Building. In 1925, a new front was added to the white-enameled brick building by William Garvey. Starting in the 1940s, it was owned by business partners George Drake and George Tsenes until they retired in 1970.

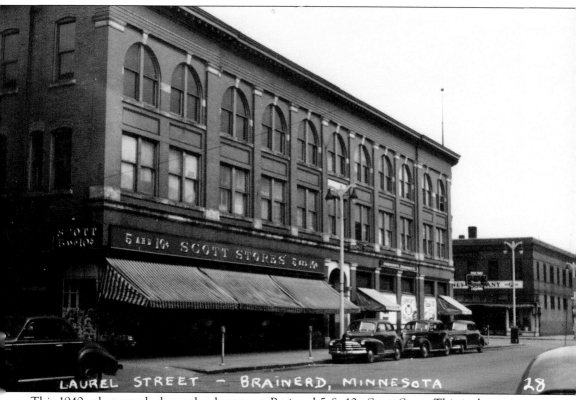

LAUREL STREET — BRAINERD, MINNESOTA 28

This 1940s photograph shows the downtown Brainerd 5 & 10¢ Scott Store. This is the recipe for the store's oatmeal cookies:

1 cup raisins	1 tsp. baking soda
1 cup water	1 tsp. cinnamon
¾ cup shortening	½ tsp. cloves
1 ½ cups sugar	½ tsp. baking powder
2 eggs	2 cups quick oats
1 tsp. vanilla	2 ½ cups flour
1 tsp. salt	½ cup chopped walnuts

Boil raisins in water and drain (saving ¼ cup of the boiling water). Beat together shortening and sugar. Add eggs and vanilla; beat. Add raisin water to the shortening mixture and mix well. Sift dry ingredients together, except oats. Add flour mixture and beat. Stir in oats and plumped raisins. Stir in walnuts. Drop balls of dough on baking sheets. Bake at 350 degrees until the cookies are browned, about 10 to 12 minutes.

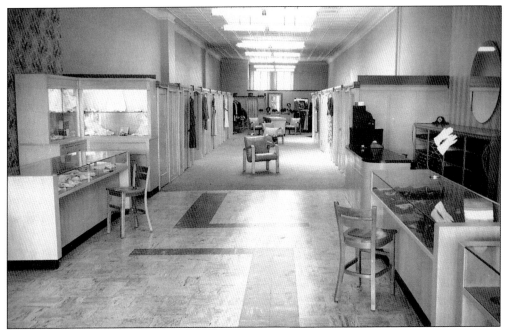

This upscale women's clothing store known as the Frances Shoppe was located on Front Street in the 1940s and 1950s. By the 1960s, it had moved to Laurel Street. Ida Kober moved from South Dakota to Brainerd in 1946 to manage the shop and eventually bought it. Later, Ken Nelson owned it.

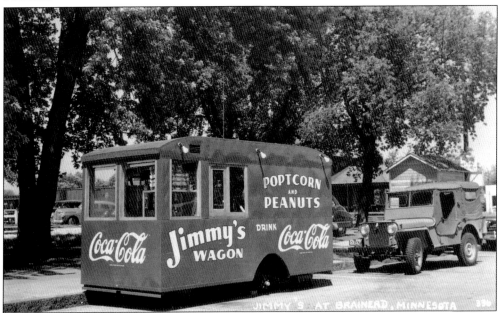

Jimmy Lutz parked his bright-red "poptcorn" wagon on South Sixth Street next to the Lyceum Building, which was a block south of the Brainerd Theater. He started his business in the days before movie theaters sold popcorn. A 1952 newspaper advertised a free stick of gum for the kids every weekend with each 10¢ box of popcorn. The business ended in 1957 when Jimmy died at age 44.

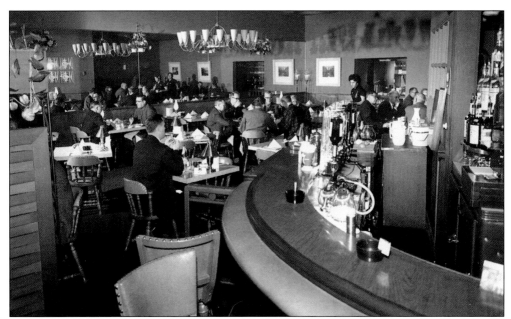

Earl Mondor started the upscale Vogue Supper Club, located at 519 Laurel Street, in the mid-1940s. Established in the Iron Exchange Building, this restaurant, with a very unique decor for those days, was a thriving business for over 20 years in downtown Brainerd. The basement had a bar section, called the Dugout; here, the Brainerd Young Women's Business Club is shown at their Christmas banquet with what looks like melting snowmen as centerpieces. Pictured are, from left to right, Peggy Arnesburger, Margaret Meyers, Pearl Bangert, Sally Fields, Dorothy Warlof, Midge Burton, unidentified, Gertrude Meyers, Leola Buchite, and Arline Hagberg.

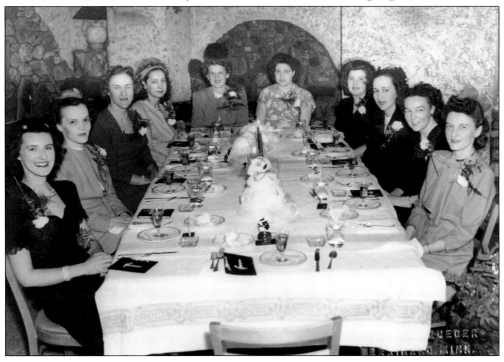

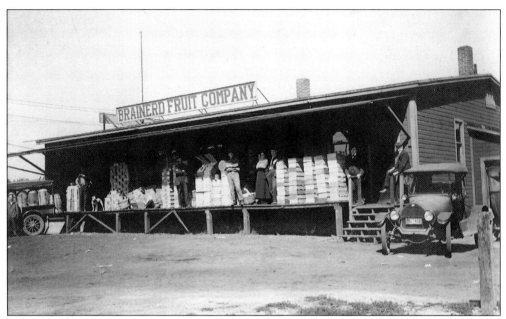

The Brainerd Fruit Company started in 1913. This 40-by-60-foot building with a basement had banana rooms, iceboxes, and even electric elevator service. Proper ventilation controlled the temperature for this wholesale company that sold fruit, vegetables, nuts, and cheese. It was eventually sold to a large chain of food distributors.

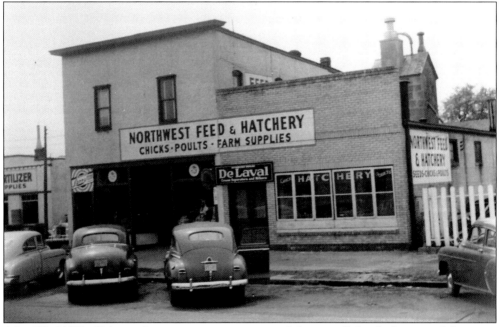

After World War II, larger farms were more economical than small family farms, and there was need for more advanced equipment. Reflecting this, more hatcheries and feed stores started in Brainerd in the 1940s. Northwest Feed & Hatchery opened in 1946 at 814 Front Street. As seen on the signs, they carried chicks, poults, and farm supplies, as well as DeLaval cream separators, one of the first centrifugal cream separators.

Five

TAKING AND MAKING

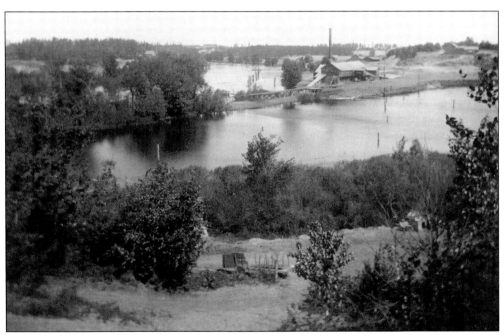

Jeremiah Howe started working at a sawmill at age 12. He came to Brainerd in 1876 and continued in the lumber business. He bought this sawmill on a backwater of the Mississippi River known as Boom Lake. The logs came down the river to the J.J. Howe Sawmill and were cut to the dimensions needed. At its heyday, this mill shipped out six boxcar loads of lumber a day.

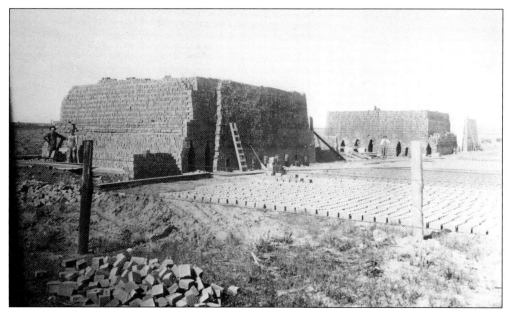

William Schwartz started his brickyard in 1876 along the Mississippi River. While other brickmakers made red brick, Schwartz made tough, durable cream-colored bricks from grayish clay he found upstream. In 1882, the first Crow Wing County Courthouse on the corner of Fourth and Kingwood Streets was made of so-called Milwaukee cream brick, as was the sheriff's house and county jail nearby. Many Brainerd buildings were made from locally made bricks.

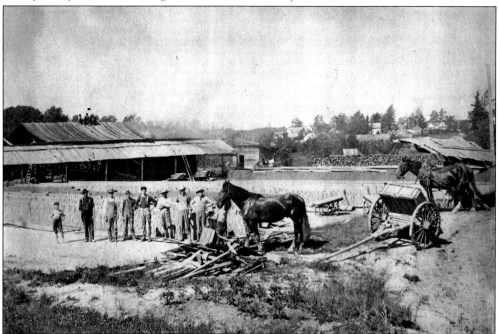

David Ebinger was proprietor of the Brainerd Brick Yards, which made red brick from about 1900 until 1918. This c. 1910 photograph shows the sons of David and Josephine Ebinger, Howard, David Jr. (on the roof), William, and Edward (holding the horse), working with their father. Twelve to fifteen men were employed, using horses to mix the clay for the bricks.

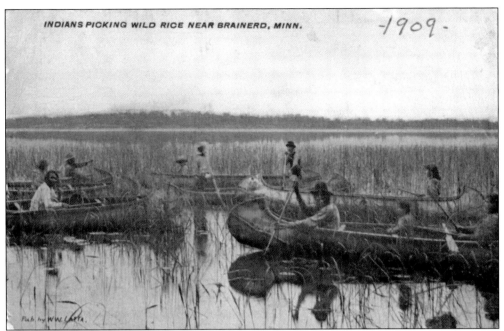

INDIANS PICKING WILD RICE NEAR BRAINERD, MINN. -1909-

Pub. by W.W. Latta.

There are 123 Rice Lakes in Minnesota, including one at Brainerd. Many are named for the wild rice grain growing in their shallow waters. Now known as a gourmet dish, it was a nutritious staple in the early Native American diet. Wild rice is harvested by beating the plant with sticks into a canoe. It is then dried, parched, and winnowed to get it ready to cook or store.

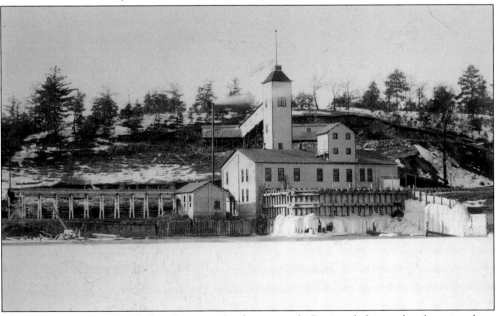

The Mississippi River and abundant nearby forests made Brainerd the perfect location for a paper mill. In 1903, Northwest Paper purchased the dam first constructed in 1888 by Charles F. Kindred. The company operated a two-grinder pulp mill on the west side of the dam until the mill was shut down in 1911 and dismantled in 1914. The mill's output was an amazing 12 tons of ground wood pulp per day.

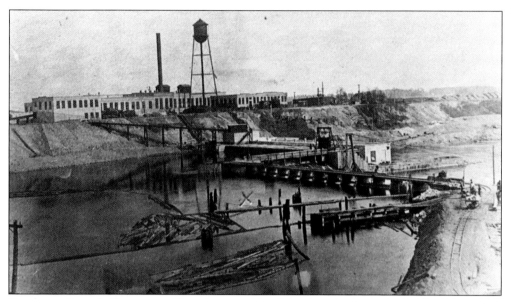

Northwest Paper built a new mill on the east side of the dam (and rebuilt the dam) from 1915 to 1917. The mill then boasted 185 employees and produced 40 tons of newsprint per day. The paper mill has been a major employer in Brainerd for most of the town's existence, changing to production of wallpaper, coated papers, or whatever was needed to stay current with the demands of the industry.

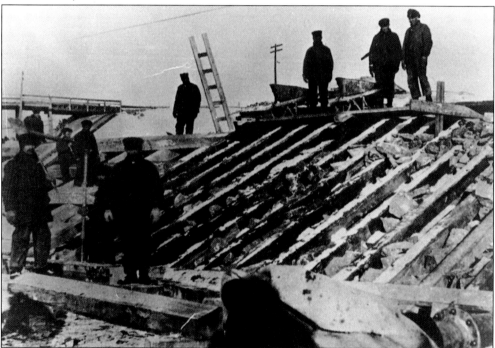

The first dam in Brainerd was completed in 1888, organized by Charles Kindred and financed by city bonds, to generate electricity for lights and for water service. As shown here, Northwest Paper rebuilt the dam in 1916, raising the height from 16 to 20 feet. The wood, rock, and steel construction held until 1950, when high water washed it out; it was replaced with concrete.

In about 1920, workers, from left to right, William Vilas, Fred Barron, Harley Strong, Walter Schwendeman, David Wayt, Mervin Pickering, and Leonard Schwendeman posed at the Brainerd Mill with machine No. 5 and its rolls of newsprint. Their bare feet gave them a better grip on the machines than leather shoes.

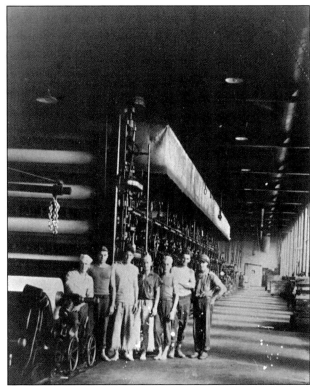

Millwrights at the Brainerd Mill around 1920 are, from left to right, Tony Schwendeman, John Lee, and George Peaslee. Lee started in 1917 as a tinsmith, earning 45¢ per hour, and continued at the mill until 1942, when he retired as a millwright, earning 85¢ per hour.

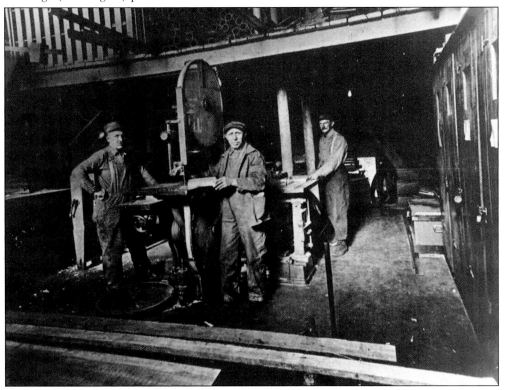

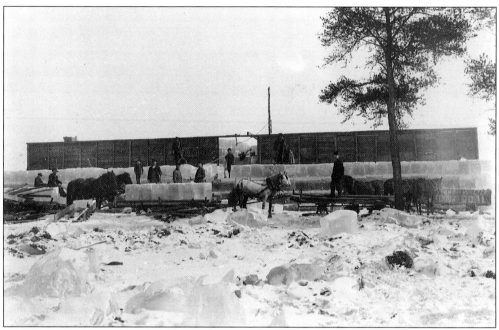

The Brainerd Ice Company harvested annually on Rice Lake when ice was about 20 inches thick. Thirty or more men would saw the ice into square blocks, pull them out with ice tongs, and load them onto horse-drawn sleds. An annual harvest could be 5,000 pounds of ice. These ice blocks were stacked in an icehouse with sawdust used as insulation between the blocks. They would stay frozen, and ice deliverymen would deliver ice throughout the summer, much of it being placed in home iceboxes. In April 1899, the ice company charged $2 per month to have ice delivered daily. One could save 25¢ a week by having delivery only four times per week. In 1893, during a typhoid epidemic, the cutting of ice located below any sewer in the city limits was banned.

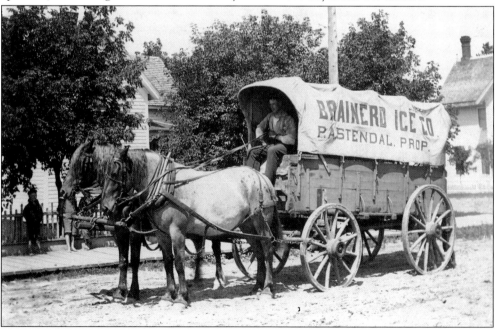

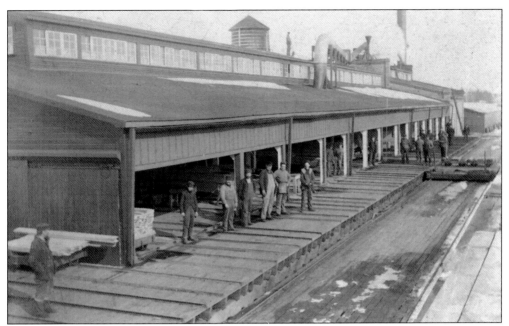

Mons Mahlum came here from Norway in 1888 at age 22. He was a grocer for eight years. In 1903, a Sons of Norway Lodge was organized with Mahlum as the president. He was active in other civic affairs, too. By 1914, he had established the Mahlum Lumber Company, with a planing mill, at the corner of Eighth and Laurel Streets. He expanded the business to include mills at other Minnesota towns. In 1918, he hosted a party for his employees and their families at his cottage on North Long Lake. While his wife prepared dinner and a lunch, the crowd enjoyed motorboating, bathing, and fishing. Mons Mahlum reportedly caught a whopper. The lumber company grew and, eventually, was sold to Lampert Lumber, another familiar Minnesota lumber company.

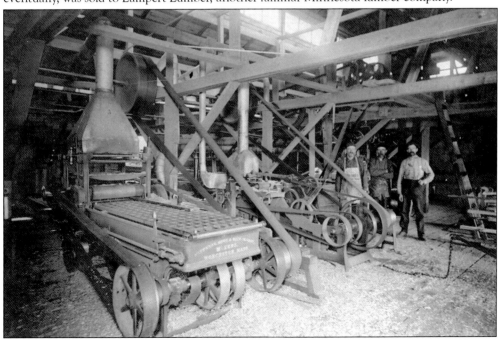

Clarence Smith came to Brainerd in 1882 with his family. He drove milk, feed, and laundry wagons and dray, hearse, and fire hose carts. He worked on Parker's streetcar line and helped build and install Brainerd's first telephone system. He and his wife, Freda, had four daughters and ran a dairy. Their daughter Alberta married Obert Benson and continued to live on the family farm at 1002 South Sixth Street, pictured here.

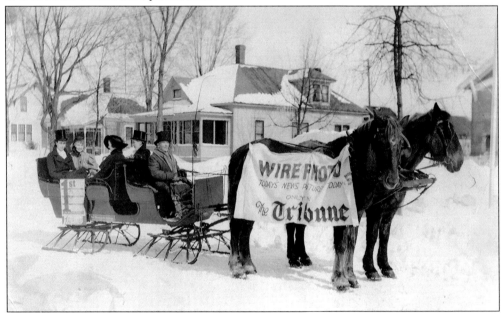

Brainerd's earliest newspaper was the *Tribune*, started in 1872 by M.C. Russell, Brainerd's third mayor. Other newspapers include the *Brainerd Dispatch, Journal, Journal Press, Daily News, Arena, Observer,* and *Crow Wing County Review*—some of these being the same newspaper with a changed name. This 1936 photograph, with Clarence Smith driving the sleigh and a *Tribune* advertisement, may have been taken at a parade.

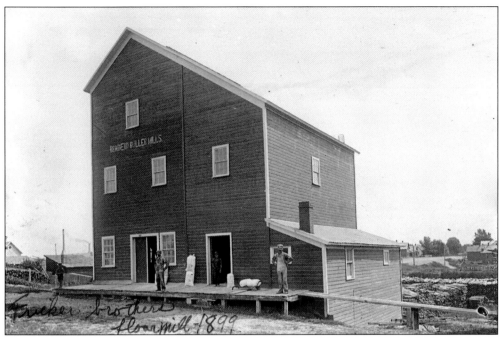

Brainerd Roller Mills was located at 701 South Tenth Street. Operated by German-born brothers George and Phillip Fricker, it manufactured Brainerd's Best Flour (including rye, buckwheat, and graham varieties) and feed. This photograph shows the mill in 1899; in 1908, it was destroyed by fire. By the next year, George was working for a confectionery, and Phillip was working at the railroad.

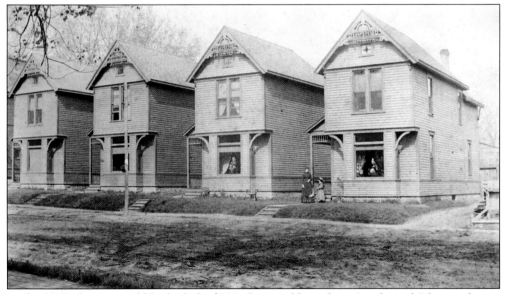

In the 1870s, houses could be built for $200. One could purchase "ready-made" houses from a Brainerd manufacturer for $100 to $500. It is unknown who built this row of homes on the 700 block of South Eighth Street in 1888, but some buildings are still recognizable today. This was the year Mayor Hemstead urged that a building inspector be appointed because of the busy building season.

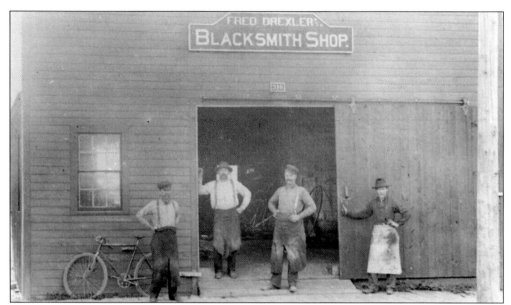

Fred Drexler's Blacksmith Shop was located at 316 South Sixth Street. As well as usual blacksmith articles, Fred was known for his fishing spears. He and his employees made thousands each year to ship throughout the United States. The unique feature about a Drexler fishing spear is that each is designed to suit the fish being sought in that locality. Pictured from left to right are Paul Kalucha, Fred Drexler, John McNaughton, and Charlie Smith.

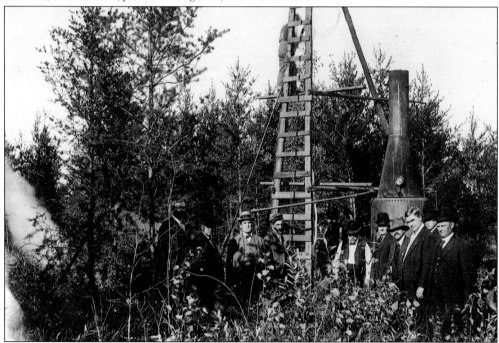

Minnesota is known for three great iron ranges—the Vermilion, the Mesabi, and the Cuyuna. The Cuyuna is in Crow Wing County. Mining has also been done in south Brainerd. John Oscar Martin was the superintendent of this Brainerd-Cuyuna Mine. The company sunk the shaft in August 1913, but the venture proved too costly, and operations ended in November 1915.

Six

PROTECTING AND SERVING

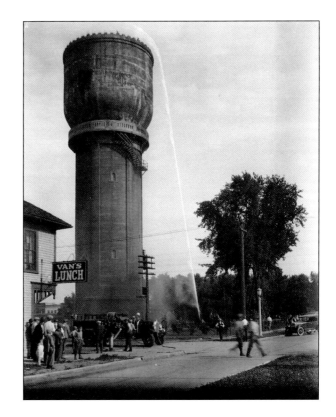

Brainerd's much-photographed landmark water tower, located on the southeast corner of Sixth and Washington Streets, took four years to build. The new system, including four wells and 22 miles of pipe, was completed in 1922. It was the first all-concrete elevated city water tank in the United States. Standing 141 feet tall, it holds 300,000 gallons. The 40-foot diameter bowl has been dry since 1960.

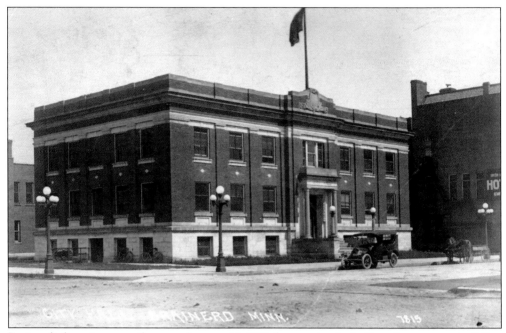

Brainerd's first city council met on January 11, 1873, but not in city hall, as there was no building yet. The fire department hose house provided council rooms upstairs. In 1902, some rooms at the Park Opera House were rented for official city use. It was not until 1914 that the city council decided to build Brainerd City Hall on the northeast corner of Fifth and Laurel Streets.

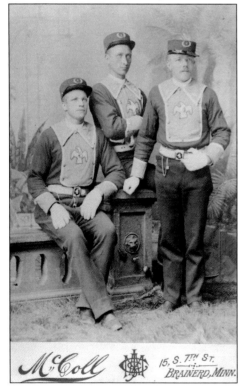

Brainerd's Fire Department was organized in 1872. Water was obtained from four city wells. The Fourth Ward Eagle Hose Company was organized in 1887. By 1888, Brainerd had 72 hydrants. In 1890, Peter Petersen (left) was elected captain, a position he held until his death in 1936. Other firefighters shown are Mr. Thompson (center) and Mr. Robertson.

This Brainerd Fire Department Fourth Ward Hose House was located in southeast Brainerd between Norwood and Oak Streets. A two-wheeled cart was kept in this hose house. Those identified in this 1904 photograph are Alpha Fagelstron (the boy with the bicycle), Fred Brandt (standing in the first row), Chief Peter Peterson (sitting in the first row), and behind Brandt, Martin Wicklund, whose son Roy was later a county sheriff.

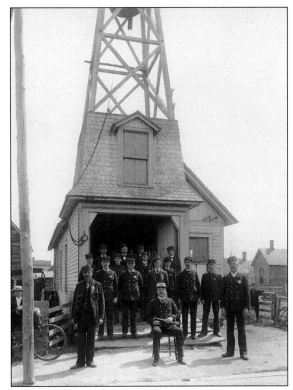

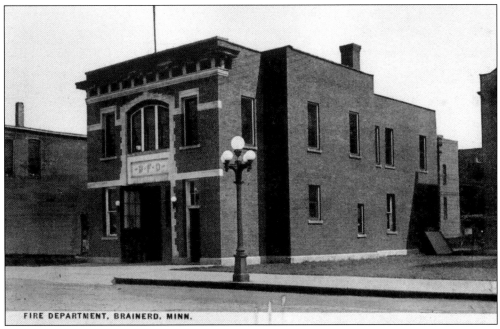

In 1914, a city bond financed the building of a new city hall, jail, and fire hall, all located at the northeast corner of Fifth and Laurel Streets. This brick structure replaced a wooden central fire hall at the same location. The part-time fire chief was Henry McGinn, who served for about 20 years beginning in 1907. Brainerd's volunteer fire department dates back to 1872.

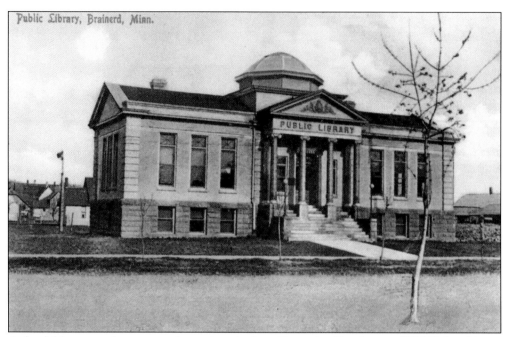

Public Library, Brainerd, Minn.

As he did for many places across the nation, Andrew Carnegie offered to pay $12,000 for a library building if the community would provide a site and arrange for maintenance. One of the community fundraisers was a train trip 60 miles north to Walker for a picnic, with the railroad donating a portion of the ticket prices to the library fund. This building was completed in 1905.

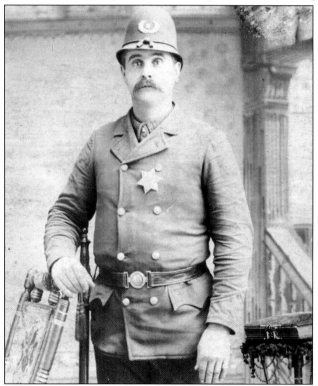

In 1883, Brainerd had 52 businessmen licensed to sell hard liquor. The license fee had just been raised from $75 to $100 per year. This is the year that Moses DeRocher Sr. was appointed policeman. He was multilingual, speaking English, French, and several Indian dialects. He is remembered for single-handedly arresting 25 men and marching them a mile to the jail. DeRocher died of dropsy in 1910.

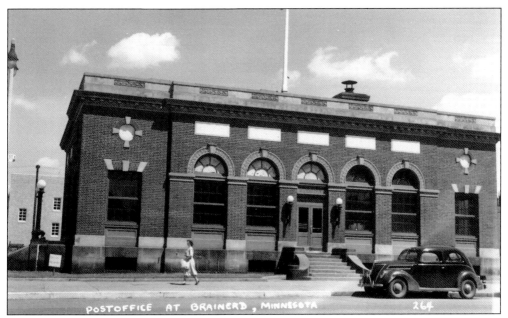

Situated on the southeast corner of Sixth and Maple Streets, this Brainerd Post Office was built in 1910. It remained in operation until 1960, when it was demolished and replaced with the current post office at Fifth and Laurel Streets. Prior to 1910, the post office was located in various buildings with the storekeeper receiving a moderate salary in return for performing light duties as needed.

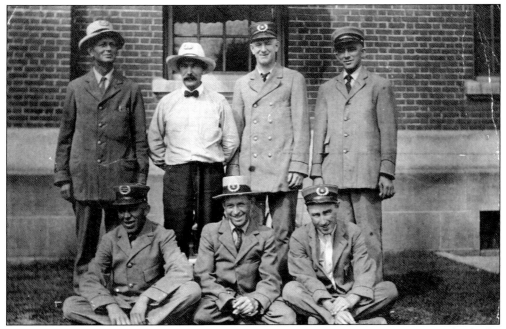

Post office letter carriers pictured in 1920 are, from left to right, (sitting) Albert Englund, Charles Risk, and Asa French; (standing) Russell Cass, Christian Nelson, Ray Hall, and Fred Englund. Free mail delivery began on February 4, 1901, in Brainerd, which required the installation of street signs and house numbers.

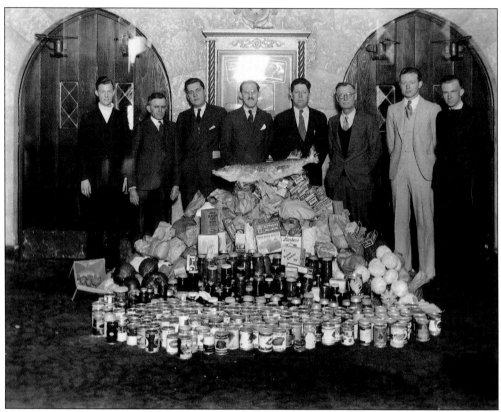

During the Great Depression, the Lions Club paired up with the Paramount Theater to present a "picture show" with the admission being an article of food to be given to the poor through the recently organized Brainerd Community Relief Fund. Here are some Lions Club members and Paramount employees posing with a mountain of donated food in December 1932. One wonders who gave (and received) the big fish.

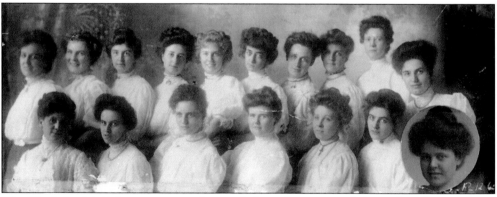

The "Bachelor Maids" was a group of young ladies who organized themselves for social and welfare purposes. They did charitable work, especially for the elderly, in the area. They produced entertaining programs of many types, including a successful vaudeville show for Brainerd and nearby towns. This photograph shows the group in 1909.

The Ancient Order of Hibernians is an Irish Catholic fraternity founded in New York in 1836 and established in Brainerd in 1897. Their motto is "Friendship, Unity, and Christian Charity." The ladies auxiliary of the Brainerd order is seen here, from left to right, (first row) Margarete Larkin, Kate Early, Anna Smith, Rose Clark, and Mame Reilly; (second row) Alice Adair, Cecilia Ann Rowley, Nellie Quinn, Margaret Goedderz, and Hulda Brady.

Service Flags inspired the formation of Gold Star Mothers Clubs. Families with armed service members hang a flag with a star for each child in the armed services. Blue stars represent the living; gold stars represent the deceased. The Gold Star parents at this 1967 luncheon include Karen and George Campbell, Clara Viken, Marguerite Steece, Ragnhild Lee, Georgia Mohler, Ella Kleinschmidt, Bertha Strobel, and Gloria and Max Kerben.

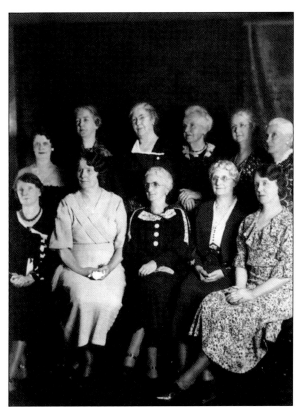

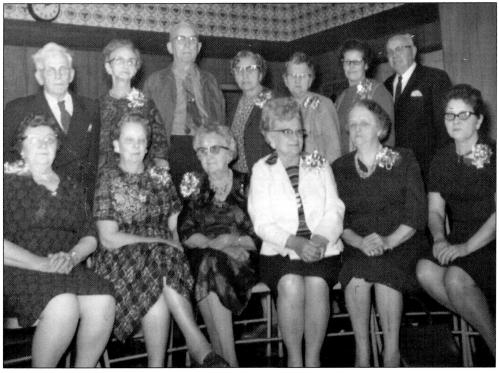

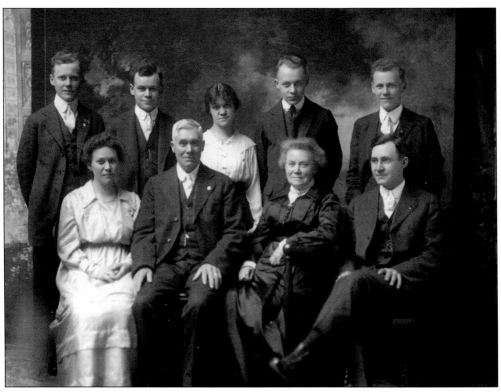

Jessie and Robert Crust flank Edward Sr. and Mary Crust in the first row. In the second row are, from left to right, Edward Jr., James, Elizabeth, George, and Ernest. Edward Crust Sr. and his wife, Mary, of Scotland came here in 1883 when east Brainerd "was just a cow pasture." As well as blacksmithing for the railroad, Crust was very active in civic affairs, including serving a term as mayor.

Minnesota governor C. Elmer Anderson was born and died in Brainerd. In 1938, at age 26, he was the youngest in the nation to serve as lieutenant governor; then, he served as Republican governor from 1951 to 1954. Other positions he held included mayor of Brainerd and, as a child, Brainerd paperboy. A segment of Highway 371 near Brainerd is named after him.

Seven

CARING AND CURING

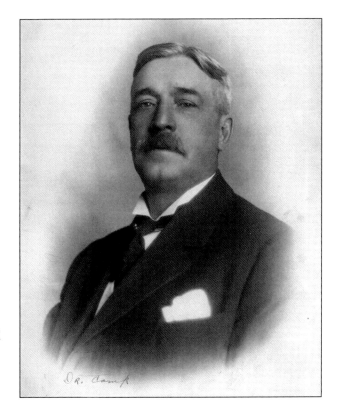

Dr. James Camp arrived in
Brainerd in 1884. A surgeon, he
built the 15-bed Lumbermen's
Hospital in 1890 and, two
years later, constructed another
that was sold in 1900 to the
Benedictine Sisters Hospital
Association, which became St.
Joseph's Hospital. Dr. Camp,
known as a humanitarian, served
as physician in the 1898 Leech
Lake uprising. When he died in
1914, many of his books were
donated to the public library.

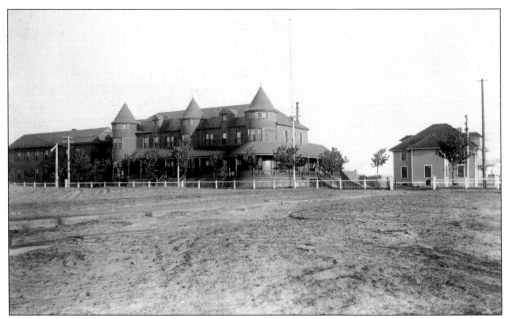

The photograph above shows the Northern Pacific Hospital. It was located on the west side of the Mississippi River in Brainerd from 1882 to 1921. It was the main hospital for the entire railroad company. The building on the right was constructed as the nurses' residence. These quarters were designed in 1901 by the same firm that designed Grand Central Station in New York City. The photograph below shows the modern (for the times) laboratory. In the 1800s, hospitals started having laboratories for the testing of specimens, and hygienic laboratories were not regulated until 1901.

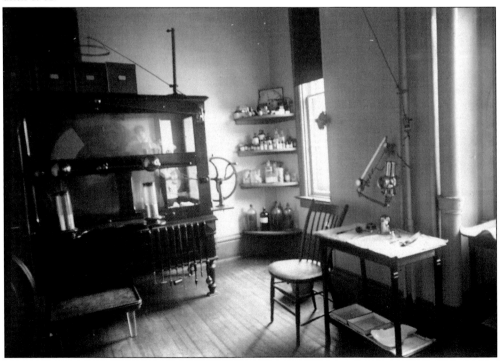

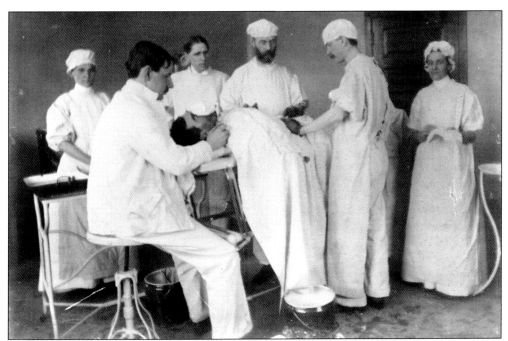

A laundry facility, as well as a new operating room, was added to the Northern Pacific Hospital in 1898. Surgery was not performed on a regular basis before the late 1800s, nor was anesthesia commonly used until then. Antibiotics were not even discovered until 1928, so many early surgeries were less than successful. This should all be kept in mind while viewing these doctors operating on a man at the Northern Pacific Hospital. The photograph below shows three nurses posing in a ward, with patients occupying most of the beds. Northern Pacific employees paid a monthly fee in order to receive health care.

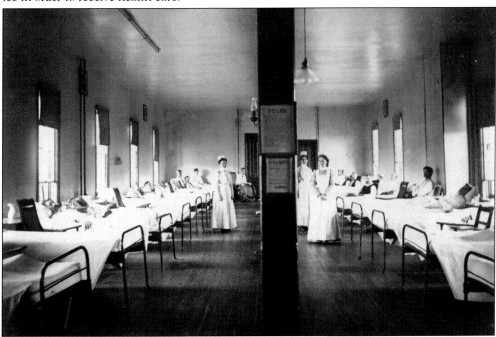

John Alois Thabes was born to Louis and Catherine Thabes on December 5, 1872, and moved to Brainerd in 1882. Dr. Thabes attended the Coreen School and Minnesota State College, and finished his education at the New York State University Medical School. Upon return to Brainerd, he opened his medical practice and worked alongside Dr. James L. Camp at the Lumbermen's Hospital until the sisters of St. Benedict purchased the Lumbermen's Hospital and opened up St. Joseph's Hospital at 523 North Third Street. In 1921, Dr. Thabes was named chief of staff and he retired in 1947. In 1922, Dr. Thabes was appointed to the Minnesota State Board of Health, an honor that few physicians have achieved. Dr. Thabes also served as a member of the school board and was the city health officer. He died July 2, 1953.

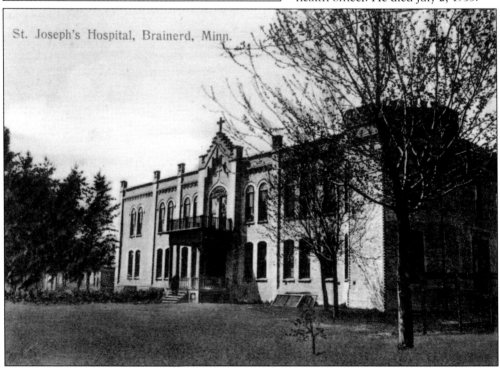

St. Joseph's Hospital, Brainerd, Minn.

Dr. Werner Hemstead came to Brainerd in 1882 at age 22 to be a surgeon's assistant at Northern Pacific Hospital. From 1887 to 1918, he had his own private practice, served terms as mayor and state legislator, and was influential in business. The Hemsteads built a large Colonial-style home at 303 North Fourth Street in 1903. He became physician at St. Cloud and Fergus Falls reformatories, retiring at age 87. (Courtesy of Kathy Bjork.)

Christian S. Reimestad came from Norway as a toddler. After spending some time as a cowboy, he graduated from the University of Minnesota. He came to Brainerd in 1896 and, later, became the internal medicine specialist at the Northwestern Medical and Surgical Association. He is remembered for kindness and generosity. Sometimes, when asked by a patient what he was owed, he would reply, "Do the best you can, my friend."

Dr. Joseph Nicholson was born and raised in rural Litchfield, Minnesota. He received his doctorate of medicine in 1903 from the University of Minnesota. Dr. Nicholson opened the Northwestern Hospital in 1908 in the former Walter Davis home. Located at the northeast corner of North Broadway (now Eighth) and Kingwood Streets, the hospital was a surgery center with an operating room, X-ray machine, laboratory, and 25 beds; it also operated a training school for nurses. In 1920, Northwestern Hospital became Northwestern Medical and Surgical Association. In 1922, a three-story addition was erected to the east, increasing its capacity to 72 beds. In 1924, the Northwestern Hospital went into receivership and, in 1927, became Kingwood apartments. Others practicing with Dr. Nicholson were Dr. Christian Reimestad, Dr. Elmer Erickson, and Dr. Charles Nordin.

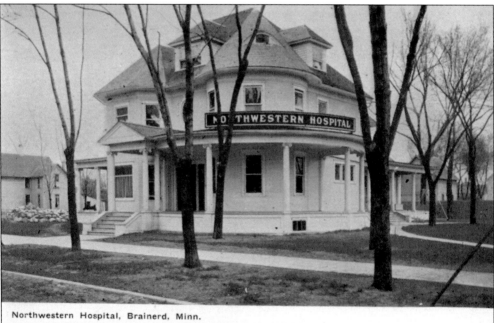

Northwestern Hospital, Brainerd, Minn.

Helen Bane was born in 1913 in Brainerd. She graduated from Brainerd High School in 1929 and then attended medical school (one of four women in her class). When she and her husband, Judge Henry Wadsworth Longfellow, began having children, they returned to Brainerd. Dr. Longfellow set up her practice in 1945 and retired in 1981. She is remembered for delivering babies, treating illnesses, and always being "on call."

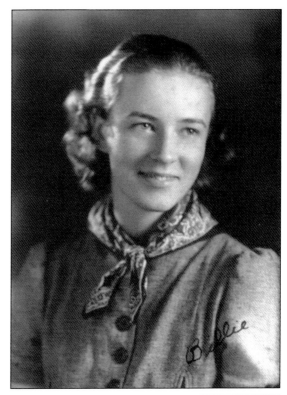

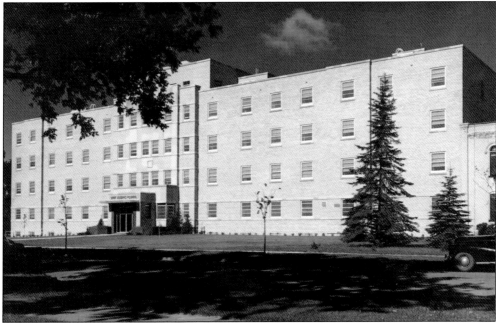

After the Benedictine sisters acquired St. Joseph's hospital in 1900, a two-story wing in 1902 added 35 beds and other improvements. In 1922, another two-story wing added 10 private rooms, living space for the sisters, and a chapel. This photograph shows St. Joseph's Hospital after a major addition to the south in 1953. The older hospital is still visible at right.

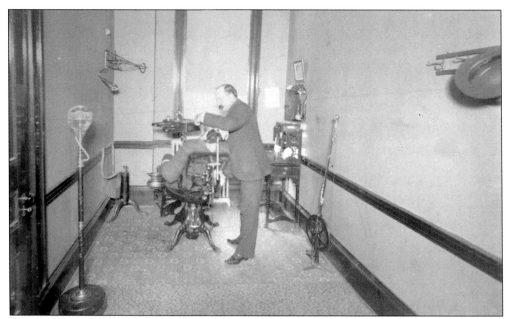

Before permanent dentists came to Brainerd, traveling dentists would come and advertise their services but soon move on. Surely, the residents welcomed the arrival of the first permanent dentist in 1883. Here is Dr. Henri Ribbel working in his office. After three decades of service, he retired. By then, his son George was a dentist, too, partnering with Brainerd's second dentist, Dr. John L. Fredericks. The house, located at 413 North Fifth Street, was built by Dr. Henri Ribbel when he and his wife, Martha, moved to Brainerd. It is where they raised their two sons, Kenneth (who died from pneumonia in 1917 at age 26) and George. The home was built next door to the Congregational church, of which the Ribbels were staunch supporters.

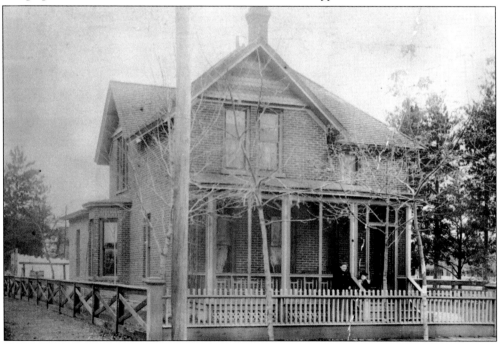

Eight

PLAYING AND COMPETING

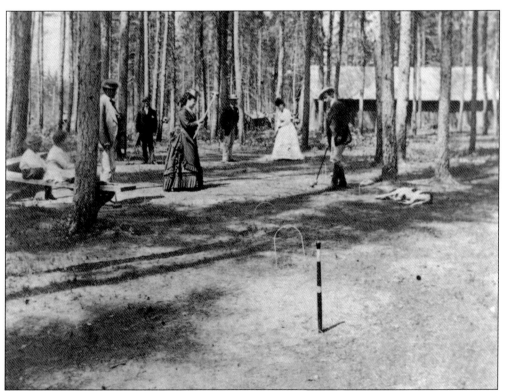

Built by the Northern Pacific Railroad in 1871, the Headquarters was Brainerd's first hotel. The three-story structure contained over 50 rooms with overhead reservoirs to pipe water into them. Croquet was as popular then as golf is today. Here, early Brainerd physicians are enjoying the game with family members at the croquet grounds at the Headquarters Hotel. In 1882 a kerosene lamp exploded, causing a fire that destroyed this Brainerd landmark.

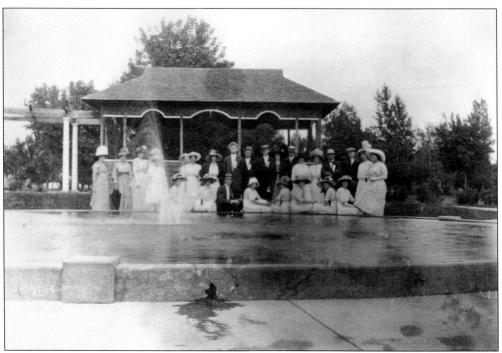

When Brainerd was platted, there was a four-block section labeled Gregory Square, named for the first president of Northern Pacific Railroad Company, John Gregory Smith. In 1887, Gregory Park, with a bandstand in the center, was enclosed with a fence. A destructive tornado struck in 1898, toppling many trees and causing much damage. In 1909, a concrete wading basin with a fountain was installed. In 1912, a new bandstand was built, which was restored in 2010. One can see the cut-stone gateway that was constructed in 1930. This residential area park is still well used and appreciated by Brainerd residents.

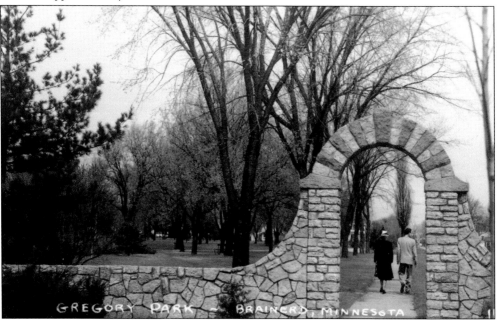

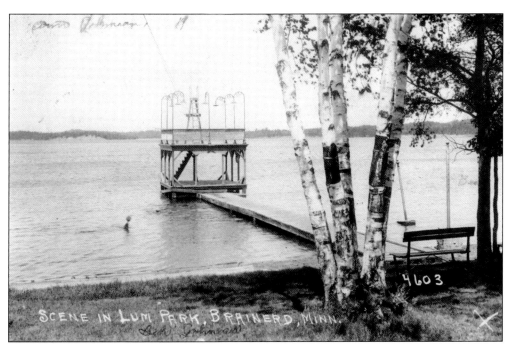

SCENE IN LUM PARK, BRAINERD, MINN.

In 1909, while Leon E. Lum was platting an 18-acre piece of land on the southeast side of Rice Lake for a resort, he heard that the city wished for a park on Rice Lake, so he promptly decided to donate those 18 acres. The location had a sandy beach and a point of land ideal for a dock. Tree varieties in the area included white birch, oak, elm, aspen, white pine, red pine, and eastern hemlock. A creek meandered through the forest to the lake. When Leon Lum (an attorney and legislator) died in 1926, his brother Clarence donated more land, bringing the total to 38 acres. A large slide in the water was added in the 1930s. Whenever water-sport activities were planned, Lum Park was the perfect location. Generations of Brainerd families and visitors have enjoyed the beautiful beach, fishing pier, playground, and modern campgrounds.

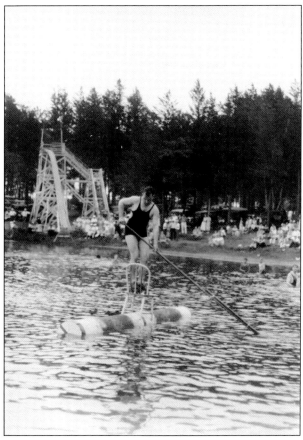

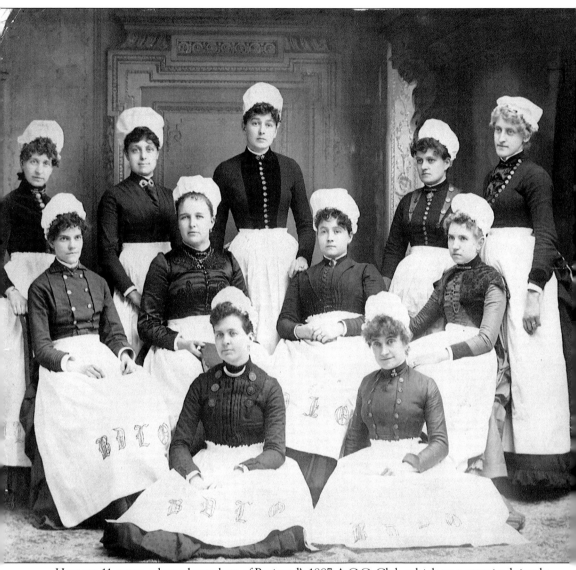

Here are 11 apron-adorned members of Brainerd's 1887 A.C.C. Club, which was organized simply for the pleasure of cooking and baking. Note the interesting decorative buttons on their clothing. Prominent charitable leader Mollie (Mulrine) Snyder organized this practical club in December 1884. Mollie Snyder was elected president, and Sarah Kindred was elected secretary-treasurer. Other members pictured are: Belle (Low) Rosser, Effie (Halstead) Brooks, Mrs. Charles Smith, Sarah Elizabeth (Guest) Kindred, Belle (Mulrine) Howard, Gertrude Fernald, Mrs. Fred Cable, Mrs. Wilson, Emma Graves, and Mrs. Charles Shaw. Some members not in the photograph are Louise (Smith) Halstead, Maud (Sleeper) Hazen, Nellie (Chase) Hazen, Blanche (Sleeper) Smith, and Agnes Mulrine. They met every other week at their homes for dinner. The meal for one meeting consisted of soup, fish, turkey, vegetables, puddings, bread, cake, coffee, tea, salad, and cranberry sauce—with each item prepared by a different member.

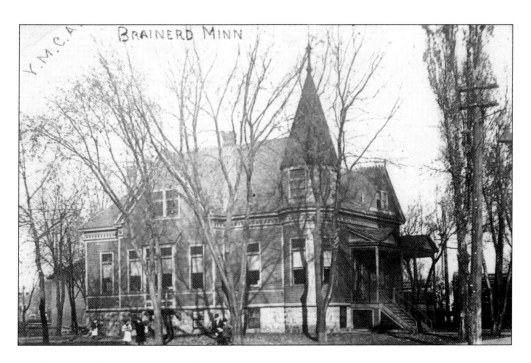

Northern Pacific Railroad wanted to provide a wholesome alternative to saloons for its young workers, so it offered to build this Young Men's Christian Association building on the northwest corner of Sixth and Front Streets. The building was finished in 1889 and was used almost continuously, except for a year in the early 1920s when it was closed for repairs, improvements, and alterations, until 1946, when it was torn down. When Brainerd celebrated its 50th birthday, the YMCA served as the homecoming registration headquarters, as seen below. Lillian Webb (on the bottom step) was chairman of the registration committee. Her help was often sought for projects of civic betterment.

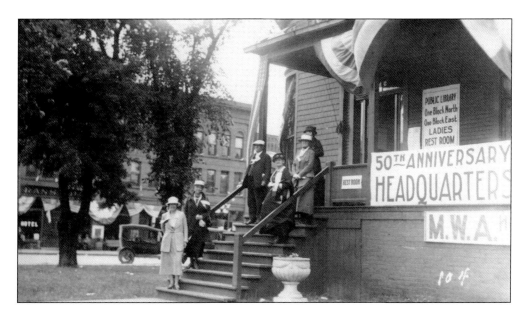

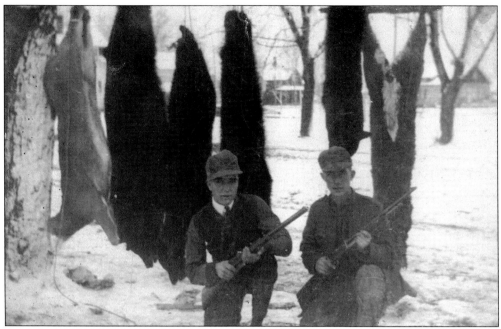

Ami Shanks, a barber and welder, came here in 1897. He and his son Howard display the results of a successful hunt: a mother bear, three cubs, and two deer. Ami was also a fisherman. He was witnessed catching a 27.5-pound northern pike and claimed he once caught a 48-pound fish. Howard operated Shanks Standard Oil service station on the corner of Front and South Eighth Streets.

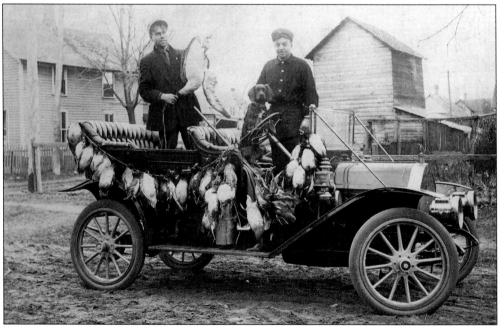

Elmer Forsberg (left) and Joseph Midgley show off their goose and duck hunting skills, displayed on a Maxwell automobile in about 1910. At that time, both men worked as machinists at the Northern Pacific Railroad shops and both resided on Northeast Fourth Avenue in Brainerd, the likely location of this photograph.

CAUGHT NEAR BRAINERD, MINNESOTA

Nowadays, Brainerd has a variety of organized fishing opportunities. There are fishing clubs, contests, guides, tournaments, and more. As early as 1926, Brainerd had a fishing club with over three dozen members. But most fishermen go out onto the lakes or fish from shore with a buddy or a grandchild or alone. This is a large-mouth bass. Some other prevalent fish are walleye, crappie, sunfish, perch, muskie, and northern pike.

Here is Louis Hostager with his large catch of fine, big fish. Hostager's family name was actually Nelson, but being there were so many Nelsons as to cause confusion in mail delivery, it was changed to Hostager. This was a common occurrence among immigrants in those days. Hostager worked as a bookkeeper for Willis Lively of the Lively Auto Company. Later, he was a distributor for Philco radios in Brainerd.

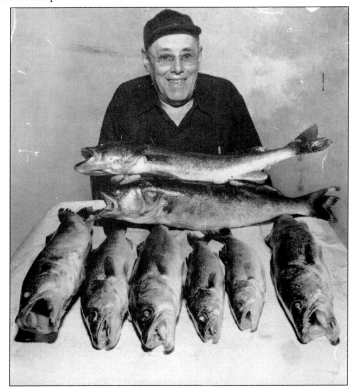

W.A.M. "Billy" Johnstone, also known as Alphabetical Johnstone, who served as district clerk of court for over 40 years, is posing with his toboggan. In the late 1880s, the toboggan club used the wooden toboggan slides between Sixth and Eighth Streets. One slide ran east and the other ran west for the return trip. There were several other toboggan slides in the area.

The park at Boom Lake had a ski jump. In 1939, the ski club requested electric lights from the water and light board. Their request was granted, and in November, skiers and ski jumpers had three new lights, one each at the top, middle, and bottom of the ski jump. It was said that the lights were bright enough to make the nearby slalom skiing possible, too.

Over the years, Brainerd has had several roller-skating rinks. This one is the Playdium Roller Rink, which was located at 616 West Washington Street. Owners were Wade H. Murray, his son Wade M. "Bud" Murray, and daughter Jean E. Murray. Jean is standing beside the phonograph. This rink was constructed after World War II when supplies were hard to acquire, and it was in business for 20 years.

In January 1927, the Brainerd Business and Professional Women's Club had a members-only masquerade party at Emerson's Dance Hall. There were 140 attendees in various forms of fancy dress. They danced the circle two-step, had a grand march, and made noise with party squeakers. Prizes were awarded for the best costumes. At 11:00 p.m., the evening was capped off with ice cream and wafers.

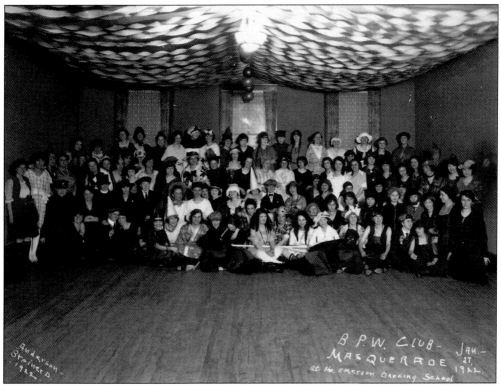

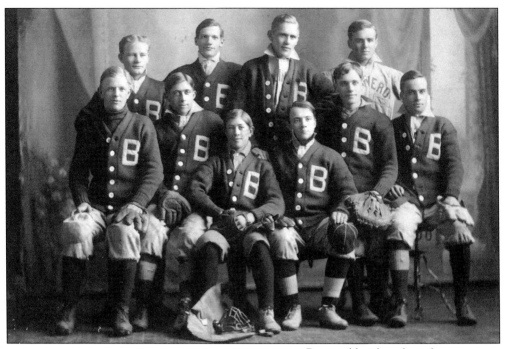

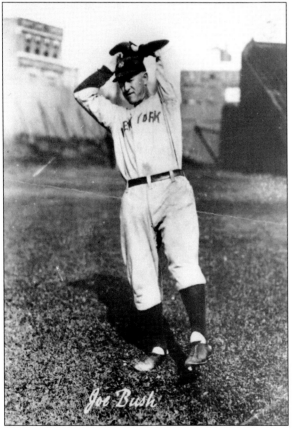

Joe Bush

Brainerd has long been known for baseball. In 1894, an amateur Brainerd baseball team was state champion. Pictured in this photograph of the 1910 Brainerd city team are Moxie Mahlum, Charles Bush, Leslie Bush, ? O'Connor, Quin Parker, Connie Osdale, Dean White, Clyde Trent, Henry Mills, and Roy Jeffrie. One may recognize the name Leslie Bush, also known as "Bullet Joe" Bush, who grew up at 907 Fir Street and went on to play Major League Baseball on several teams. At the age of 20, on the Philadelphia Athletics team, he was the youngest pitcher to win a World Series game. He has been credited with inventing the "forkball." Locally, he is remembered for waiting for his dad (a train engineer) to come home on the 12:00 train from Duluth. As they walked home through the park, Bush could be heard yodeling.

Henry Paul Dunn was a pharmacist at McFadden Drug, M.K. Swartz Drugstore, and then at his own drugstore, H.P. Dunn and Company. He served as mayor from 1911 to 1913. Here, he is throwing out the first pitch in a ball game. Brainerd has had many successful baseball teams through the years.

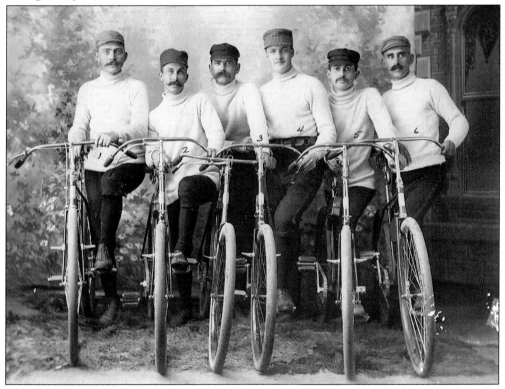

Today's bicycle riders love to bike the Paul Bunyan Trail. Bicycling was also popular in the 1890s. A cinder path in Gregory Park and a stretch on South Sixth Street paved with cedar blocks were two well-used riding routes. Pictured are six ready-to-ride Brainerd citizens, from left to right, Fred Farrar, Dr. Oliver T. Batcheller, Allen Ferris, Samuel Adair, George LaBar, and William Johnstone.

In this 1915 photograph of a North Fifth Street race, the old fire hall is seen in the background. These hot-rodders are unidentified, but the first car-owner in Brainerd was known to be Henry Rosko in 1906. He and his brother Pete ran the Rosko Brothers Garage on Ninth and Laurel Streets. Henry was said to have brought the first airplane, hydroplane, airport, and power shovel to Brainerd.

A large group of Finnish immigrants, many of them railroad workers, settled in the southeast section of Brainerd. Much of this area was swampy and was given the nickname "Frog Town." This 1906 photograph shows eight young men who referred to themselves as the Frog Town Gang. From left to right are (first row) William Erickson, Charles Johnson, and John, Gustaf, and Hilding Swanson; (second row) Ralph Hallquist, Grant Hammerstein, and Gothfred Swanson.

Here is Brainerd's women's high school basketball team in 1902. From left to right are (first row) Anna Gorenfloe (left forward), Carrie Mahlum (right forward), Mae Willie (mascot), Edna Clouston (center and captain), Edith Smith (right guard and manager), and Mabel Brown (left guard); (second row) Lillian Clulow (right guard), Vera Nevers (right forward), Carrie Tyler (left forward), and Jane Eastman (left guard).

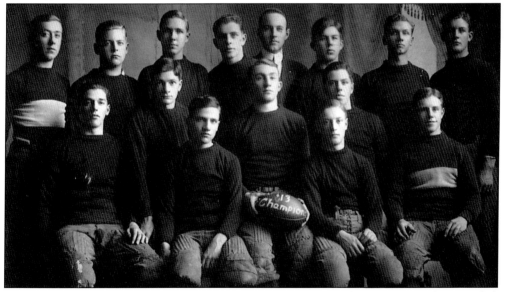

The 1913 Brainerd High School football team won the region's championship title. From left to right are (first row) Walter Koop, Bob Trent, Nels Molstad, and Bert Norquist; (second row) Walter Denneon, Captain George Day, and Arthur Hagberg; (third row) Werner Hemstead, Milton Mahlum, Floyd Warner, Eugene White, coach Harrison Sherwood, Harry Eckholm, Andy Vaughan, and Burton Orne.

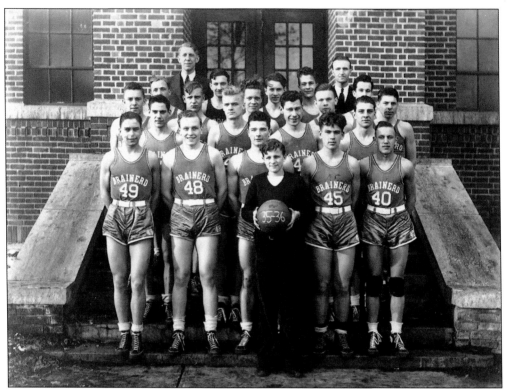

Members of the Brainerd High School boys' basketball team of 1935–1936 are, from left to right, (first row) Frank Kittleson; (second row) Method Porwall, LeRoy Peterson, Gaylord Lyscio, Dennis Gustafson, and Arthur Hautala; (third row) Carl Nygaard, Uno Toumi, Ernest Novotney, and Eugene Avery; (fourth row) Howard Hill, Harvey Shew, Gene Bierhaus, John Erickson, and Alloy Loeb; (fifth row) Clifford Whitlock, Leo Marchel, Virgil Anderson, and Bill Vadnais; (sixth row) coaches William Dammann and Walter Engebretson.

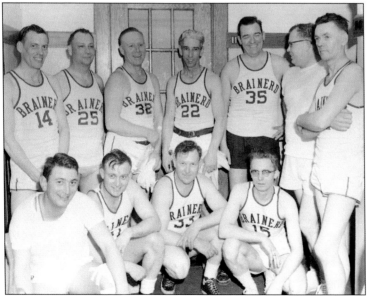

A basketball game was played on February 14, 1955, to benefit the March of Dimes. The Brainerd firemen defeated the Brainerd policemen, 45-31. The police team members are, from left to right, (first row) Richard Brunelle, William Fitzsimmons, Robert Fitzsimmons, and Herbert Erickson; (second row) William Morss, Thomas Stutsman, Louis Rofidal (police chief), John Mast, Albert Krantz, James McComas, and Karl Karlson.

Nine

ENTERTAINING

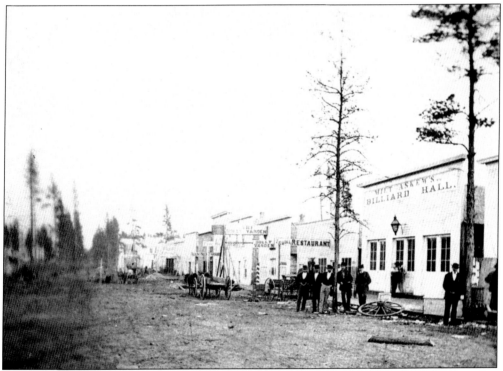

This is the south side of Front Street between Third and Fourth Streets. In the foreground is Milt Askew's Billiard Hall. Next is the Trudell Restaurant, the proprietor of which was on the first city council. Gambling was the main business of the Dolly Varden next door. Liquor could not be sold on premises, but a sign proclaimed that, upon paying in advance, "gentlemen will be furnished with refreshments."

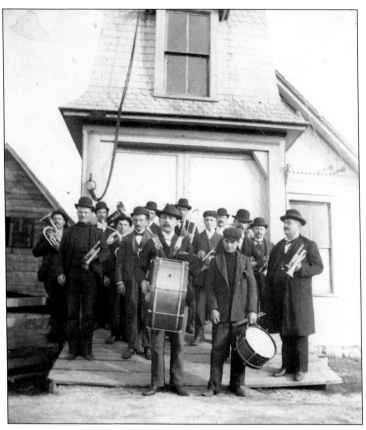

During the late 1800s and early 1900s, community bands were popular around the nation. Their musical entertainment was an important and welcome part of parades, picnics, fairs, and other celebrations. The Brainerd City Band was organized in 1882. William Dresskell, a local jeweler, served as leader for 20 years. At one time, the Brainerd City Band gave open-air concerts once a week. The left image of the city band is from 1891 and was taken in front of the Brainerd Fire Department. The photograph below was taken on July 5, 1909, at Lum Park, a popular city park located on Rice Lake.

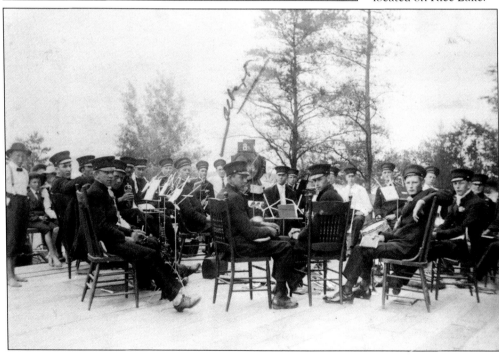

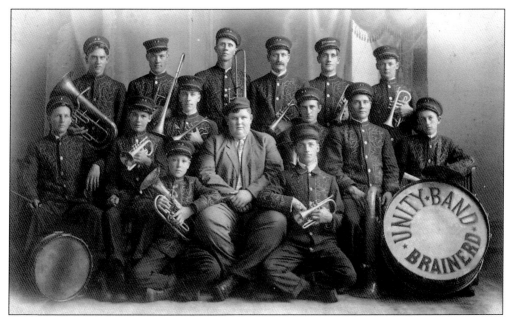

Music was a big deal in early Brainerd, and many old band photographs exist. This one with the snazzy uniforms is the Brainerd Unity Band. The man in the center without a uniform is Tom "Fatty" Wood, who was raised in Brainerd and went on to have a successful acting career in Hollywood. He worked with Charlie Chaplin in seven of his pictures.

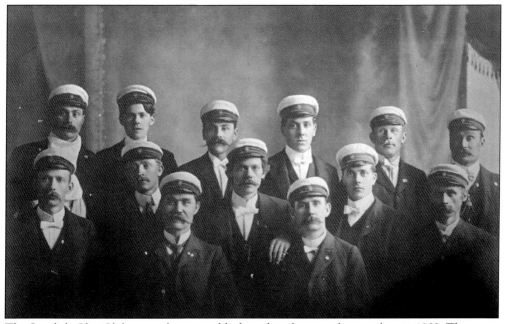

The Swedish Glee Club was only a year old when this photograph was taken in 1902. They sang Scandinavian songs. Pictured are Ole Benson, Frank Ponth Jr., Eric Olson, Martin Olson, Charles Hegblom, Swan T. Swanson, Peter M. Larson, O.W. Gronquist, Frank Ponth Sr., John Nyquist, and Eric O. Anderson.

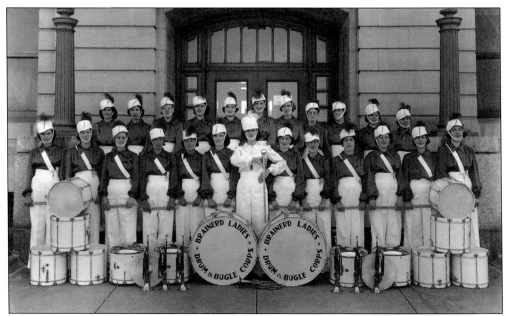

The Brainerd Ladies Drum & Bugle Corps was organized in 1936 with 16 women, which quickly grew to 36. The three initial organizers were Evelyn Rofidal, Almira Christenson, and Viola McKay. The first director was Winifred Cronk Ziebell. In the photograph above, the women are wearing white duck trousers and purple satin blouses. In the 1940 photograph below, they are wearing black and white wool snow suits for winter parades. The lady in white in the center is the majorette, Benora Christiansen. The Brainerd Ladies Drum & Bugle Corps won many awards, both local and state.

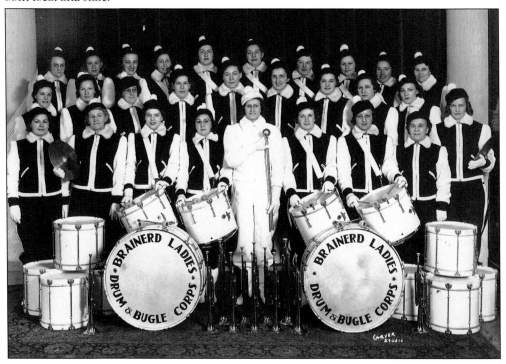

The only child of Thorwald and Louise Mysen, Jennie Mysen was born in 1886 in Brainerd. She was a piano student of Mabel Johnstone and, later, studied piano and voice in both New York and Washington, DC. She married Charles A. Lind of Brainerd, who practiced law in Washington, DC, New York, and Ohio. Known professionally as Jennie Mysen Lind, she was a noted concert pianist and music teacher.

Madeline Murphy was born in 1896 to Agnes and Patrick. This is Madeline in 1900 posing for advertisements for Shredded Wheat cereal, which debuted in 1895. The family resided at 315 North Ninth Street in Brainerd. Patrick Murphy worked in the law, loans, and insurance department of the Northern Pacific Bank Building.

Thomas R. Congdon, famous painter and etcher, was born in Pennsylvania in 1859. He came to Brainerd at age 15 as apprentice to his brother John, the master painter for Northern Pacific Railroad. Thomas painted the panels above the doors and windows of his parental home at 1004 Fir Street. In 1934, the homeowners painted over them, not knowing the value of the paintings. He studied in New York City and in Paris. In 1884, he married Ada Irene Vose, who was also an artist. The couple never had children. The Congdons painted extensively in Europe, including Spain, Switzerland, Italy, and the Netherlands. Their works are displayed in Paris, the Library of Congress, and the New York Public Library. Thomas died in 1917. The etching below is titled *The Last Kiss of the Sun*. (Left, courtesy of Janna Congdon; right, courtesy of Brainerd Public Library.)

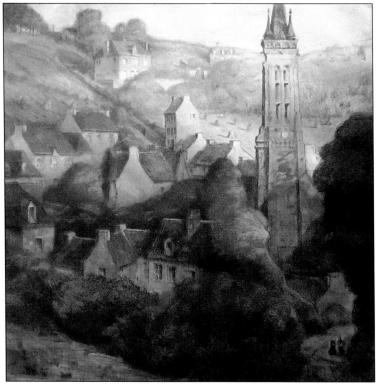

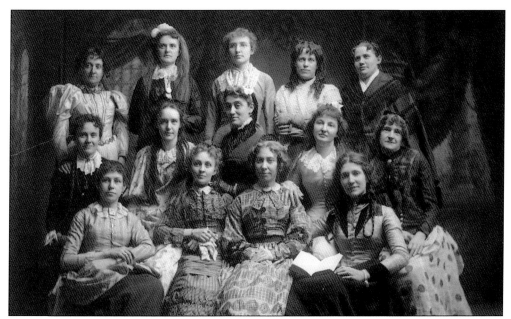

Most ladies in the 1890s wore their hair up or bound in some way. These women found it amusing to let their hair down for this photograph. From left to right are (first row) unidentified, Florence Fleming, unidentified, and Lucy Wieland; (second row) Lillian Webb, Mayme LaBar, Wilhelmina Cohen, Hattie Ingersoll, and Mattie Alderman; (third row) Effie Brooks, Mrs. M.J. Riley, unidentified, Fannie Smith, and unidentified.

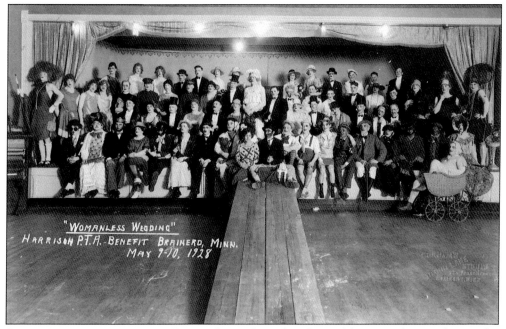

On two May 1928 evenings, 80 Brainerd men dressed up (many like women) to perform a play for the benefit of Harrison Elementary School. In the play "Womanless Wedding," Miss Isabelle Snodgrass (played by William Bane) married O.U. Poor Fish (played by Darwin Gray). The baby in the carriage is Al Ebert. "A riot of merriment" is how it was described.

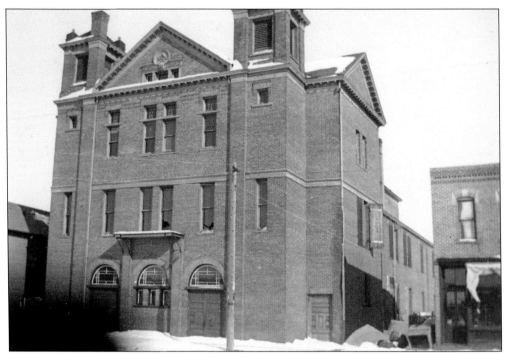

The Sleeper Opera House, built by Chauncey B. Sleeper in 1882 of Brainerd red brick, was located on Broadway (now Eighth Street) between Front and Laurel. An auditorium complete with stage, areas for orchestra and props, and 1,000 opera chairs filled the main level. On the second floor was the Masonic hall. In 1898, both the opera house and the adjacent O'Brien's Mercantile were destroyed by fire.

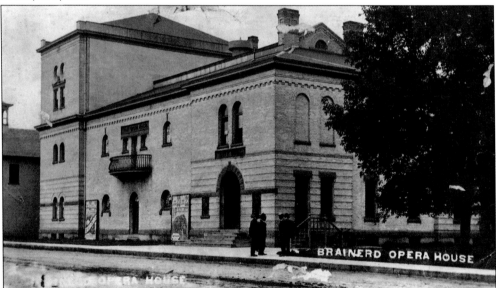

Park Opera House was built in 1890 of Schwartz cream brick and was financed by a group led by Ransford R. Wise. It was located on the north side of Front Street at Fifth Street. It had a seating capacity of 800 and was the site of vaudeville shows. Offices and meeting rooms were on the second floor. In 1929, it became the Paramount Theatre. It was demolished in 1995.

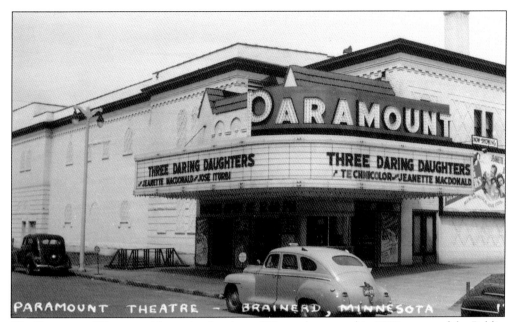

The Paramount Theatre, with seating for about 500 people, opened in 1929 as part of the Publix Theatre chain. Not only did it have deluxe new seats, it had been totally redone with an outdoor Spanish Mediterranean decor. The atmospheric ceiling had both floating clouds and twinkling stars. This 1948 marquee is advertising a musical. Owners changed over the years until it was closed in 1985.

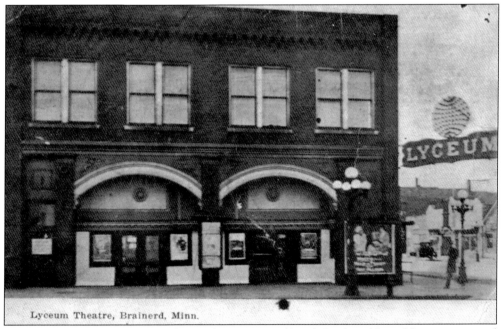

The Lyceum Building located on the southeast corner of South Sixth and Laurel Streets contained the Best Theater in 1916. Stage performances gave way to motion pictures. It reopened as the Lyceum Theater on Christmas Day 1920, with one review describing the atmosphere as "hominess, ease, cheer, and restfulness." It remained in operation until 1928.

115

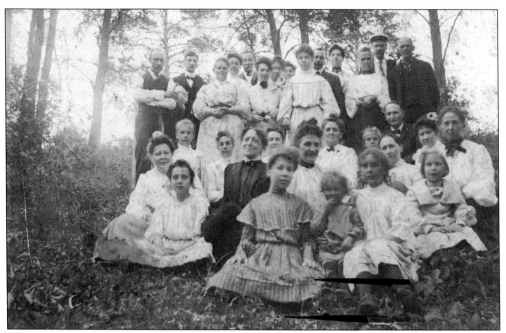

The Mississippi River flowing through the town of Brainerd and all the established city parks provide numerous scenic spots with gorgeous landscapes where an al fresco meal would be a real pleasure. This photograph shows an early Brainerd Eastern Star (freemasonry organization) picnic with family members of all ages.

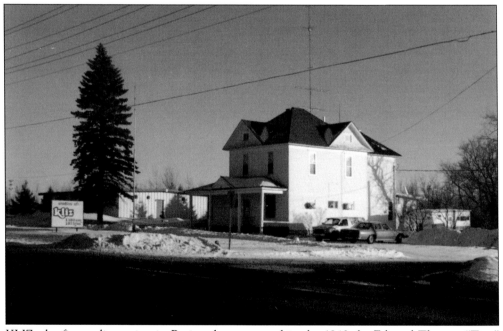

KLIZ, the first radio station in Brainerd, was started in the 1940s by Edward Thomas "Tom" O'Brien, who also operated a greenhouse. The first radio station was originally in the old O'Brien family home. Tom was the son of well-known business and civic leaders Cornelius "Con" and Elizabeth O'Brien. The "LIZ" in the call letters is named for Tom's mother.

Ten

HAPPENINGS

Brainerd has always loved parades. This 1897 parade shows Minnesota governor David Clough (governor from 1895 to 1899) and his staff riding down Laurel Street on white horses. Clough's daughter Nina was married to former Brainerd resident Roland Hartley, who later became the governor of the state of Washington.

A tragic series of incidents in 1872 is known as the Blueberry War. When Helen McArthur went missing, two Native American brothers, Gegoonce and Tebekokechickwabe, were jailed on suspicion of murder. On the first day of the trial they pled not guilty. Before the trial resumed, a mob of vigilantes broke into the jail, marched the prisoners to the corner of Front and Fourth Streets, and hanged them from the branch of a tall tree. Days later, when the sheriff noticed an unusually large number of Indians around town, he assumed they were seeking revenge so he requested help from the governor. The militia arrived, and they saw the gathering of Indians—coming peacefully to sell blueberries.

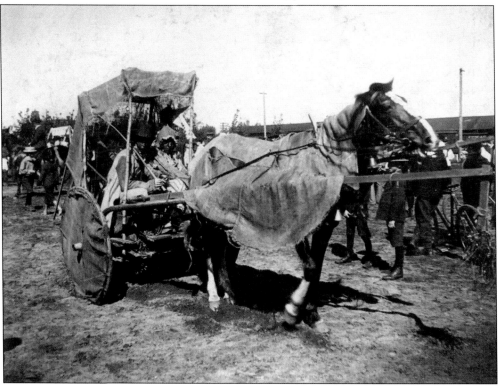

Capital punishment was banned in Minnesota in 1911. In 1896, at age 21, John Pryde was the last legally hanged man in Brainerd. A cookee for a logging camp, Pryde gambled away his money and then shot a man to steal the $42 from his pockets. He prayed for forgiveness as he was hanged.

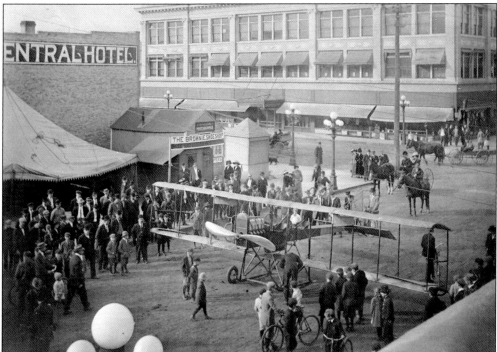

This "Jenny" airplane is on the corner of Sixth and Laurel Streets around 1915. The Jenny, made by Curtiss Company, was originally a World War I training airplane for the US Army. It is the type of airplane that aviator Charles Lindbergh used for his barnstorming stunts. Lindbergh's childhood home was in Little Falls, which is located about 30 miles south of Brainerd.

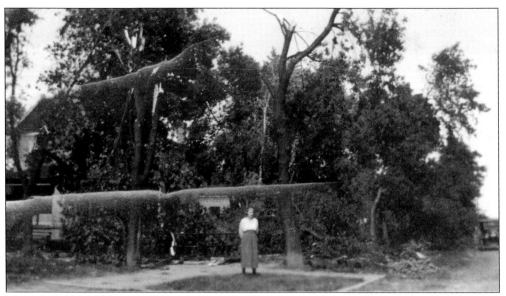

Not only did an 1898 tornado blow down most of the pine trees in Gregory Park, requiring massive replanting, but a 1919 tornado also did some damage to the area. In 1919, the tornado was 90 miles away in Fergus Falls, and there, damage and loss of lives were considerable. In Brainerd, the storm caused telephone lines to topple; this photograph shows the damage to Gregory Park.

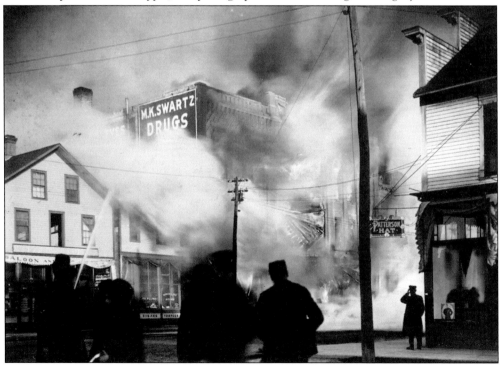

This October 1909 downtown Brainerd fire caused $175,000 in damage. It started on South Sixth Street and also burned buildings on South Fifth Street. Some businesses affected were M.K. Swartz Drugstore, George West Restaurant, Odd Fellows Building, J.C. Jamieson Saloon, and the US post office. Luckily, the mail was rescued.

The months of April and May in 1950 were a time of major flooding in this and surrounding areas. In Brainerd, the rising floodwaters caused the breaking of most of the floodgates of the Mississippi River dam at the Northwest Paper Mill. Less than a mile away, water covered the cemetery road and filled the football field at the Franklin Junior High School. Note the goalposts in the water. Maintenance crews were working 24 hours a day. The photograph below shows sandbagging downriver at Boom Lake; this was done to protect the city power and pumping station. It succeeded, and there was no contamination of drinking water in Brainerd due to the flooding.

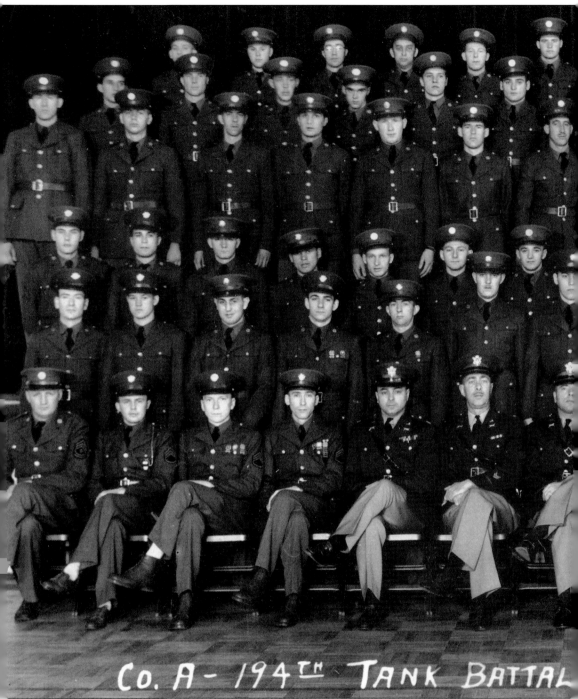

Co. A - 194ᵀᴴ TANK BATTAL

Pictured here is Brainerd's Company A of the 194th Tank Battalion of the National Guard. In 1941, they helped defend the Philippines against the Japanese. When forced to surrender in April 1942, the Japanese captors forced 78,000 Americans and Filipinos to march almost 100 miles north, with very little food and water, to prisoner of war camps. This was the Bataan Death March. Some soldiers were sent on ships to Japan. Some were forced into airless boxcars; many died of

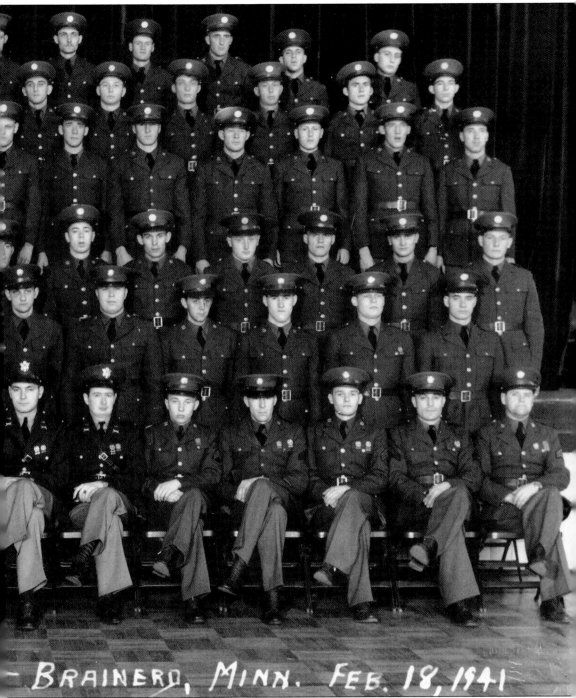

BRAINERD, MINN. FEB. 18, 1941

suffocation. Some died from exhaustion, dysentery, malaria, or malnutrition. Many were killed by their Japanese captors—bayoneted, beheaded, or buried alive. Altogether about 10,000 died. Of this group from Brainerd only about 30 returned alive. In 1955, carillon bells were installed at the Crow Wing County Courthouse as a memorial to those who lost their lives in the Bataan Death March.

Hortense McKay, who graduated from Brainerd High School in 1927, received her nursing degree in 1933. She joined the Army in 1936 and was sent to the Philippines. She worked in a primitive hospital in Bataan serving the wounded soldiers. Her Bible as well as her favorite Emerson quote "What a new face courage puts on everything!" is what kept her spirits up. After the war, she was head of nursing in several Army hospitals before retiring in 1960 as a lieutenant colonel. She was awarded a Bronze Star. Her name is one of 104 included on a monument in the Philippines, honoring the "Angels of Bataan." The book *Jungle Angel: Bataan Remembered*, written by local author Maxine Russell, tells McKay's story more fully.

This 1931 photograph shows mechanic Walter Van Doren's pride in the airplane he constructed. Originally, it had a Ford Model A engine, but he then got a new Wright Brothers motor. Three times, Walter crashed his plane with no injuries, but his fourth crash was fatal. The plane ignited in midair and crashed into a swamp, killing 24-year-old Van Doren.

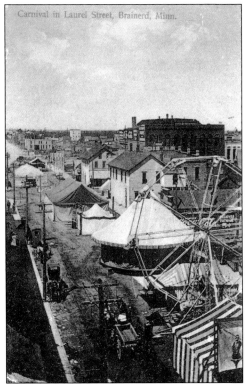

Carnival in Laurel Street, Brainerd, Minn.

George Ferris designed and constructed the Ferris wheel for the 1893 World's Columbian Exposition in Chicago. That fair became the catalyst for a surge of traveling carnival shows, such as the one shown here on Laurel Street. Ferris wheels became the most popular carnival ride. The tall white building in the far background is a flour mill. This photograph is from the late 1890s.

Brainerd had its second annual Paul Bunyan Festival in 1936. Events included "short speeches and mammoth parades," musical extravaganzas, pageants, all-star wrestling, wood chopping, and so much more to celebrate the mythical giant lumberjack. Men started growing beards in March in anticipation of the June event. Here is attorney Hilding Swanson with his wife, Alice. He served as judge for the Kangaroo Court.

In June 1946, Brainerd celebrated its diamond jubilee. Carl Zapffe Sr. wrote a 200-page book for the occasion on Brainerd history that is still consulted today. One of the many festivities was an Old-Timers Banquet; here is Marian Linneman pinning an "honor guest" tag on one of the participants.

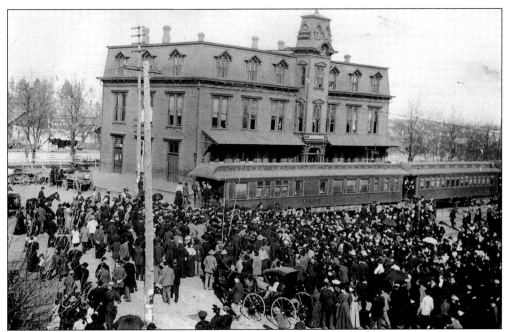

It was on October 13, 1896, that William Jennings Bryan stopped in Brainerd as part of his whistle stop campaign tour. He said, in part, that a man "has a right to use his vote in order to save his country." He gave 541 speeches in 50 days, so they were all brief. Behind the train is the railroad depot that burned in 1917. (Courtesy of Carl Faust.)

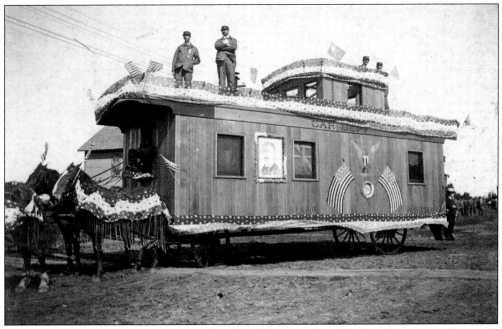

The first chapter of this book has lots of railroad photographs. This last chapter is ending with one more. A team of bunting-bedecked horses is pulling this patriotically adorned caboose on wheels in a Brainerd parade in 1904. The railroad has been an integral part of Brainerd since its beginning.

Discover Thousands of Local History Books
Featuring Millions of Vintage Images

Arcadia Publishing, the leading local history publisher in the United States, is committed to making history accessible and meaningful through publishing books that celebrate and preserve the heritage of America's people and places.

Find more books like this at
www.arcadiapublishing.com

Search for your hometown history, your old stomping grounds, and even your favorite sports team.

Consistent with our mission to preserve history on a local level, this book was printed in South Carolina on American-made paper and manufactured entirely in the United States. Products carrying the accredited Forest Stewardship Council (FSC) label are printed on 100 percent FSC-certified paper.

MADE IN THE USA